My Race Is My Gender

Q+ Public

Series editors: E. G. Crichton, Jeffrey Escoffier (2018–2022)

Editorial Board

E. G. Crichton (chair), University of California Santa Cruz; cofounder of *OUT/LOOK* journal

Jeffrey Escoffier (cochair 2018–2022), cofounder of *OUT/LOOK* journal

Shantel Gabrieal Buggs, Florida State University, Tallahassee

Julian Carter, California College of the Arts, San Francisco

Stephanie Hsu, Pace University, New York

Ajuan Mance, Mills College, Oakland, CA

Maya Manvi, San Francisco Museum of Modern Art

Don Romesburg, Sonoma State University, Rohnert Park, CA; GLBT Historical Society

Andrew Spieldenner, Cal State University San Marcos; MPact: Global Action for Gay Health & Rights; United States People Living with HIV Caucus

The Q+ Public books are a limited series of curated volumes, based on the seminal journal *OUT/LOOK: National Lesbian and Gay Quarterly*. *OUT/LOOK* was a political and cultural quarterly published out of San Francisco from 1988 to 1992. It was the first new publication to bring together lesbians and gay men after a decade or more of political and cultural separatism. It was consciously multigender and racially inclusive, addressed politics and culture, wrestled with controversial topics, and emphasized visual material along with scholarly and creative writing. *OUT/LOOK* built a bridge between academic inquiry and the broader

community. Q+ Public promises to revive *OUT/LOOK*'s political and cultural agenda in a new format and revitalize a queer public sphere to bring together academics, intellectuals, and artists to explore questions that urgently concern all LGBTQ+ communities.

For a complete list of titles in the series, please see the last page of the book.

My Race Is My Gender

Portraits of Nonbinary People of Color

EDITED BY STEPHANIE HSU
AND KA-MAN TSE

Rutgers University Press

New Brunswick, Camden, and Newark, New Jersey

London and Oxford

Rutgers University Press is a department of Rutgers, The State University of New Jersey, one of the leading public research universities in the nation. By publishing worldwide, it furthers the University's mission of dedication to excellence in teaching, scholarship, research, and clinical care.

Library of Congress Cataloging-in-Publication Data
Names: Hsu, Stephanie, editor. | Tse, Ka-Man, editor.
Title: My race is my gender: portraits of nonbinary people of color / edited by Stephanie Hsu and Ka-Man Tse.
Description: New Brunswick: Rutgers University Press, [2024] | Series: Q+ public
Identifiers: LCCN 2023047877 | ISBN 9781978823945 (paperback) | ISBN 9781978823952 (cloth) | ISBN 9781978823969 (epub) | ISBN 9781978823983 (pdf)
Subjects: LCSH: Gender-nonconforming people—United States—Social conditions. | Minorities—United States—Social conditions. | Gender-nonconforming people—United States—Identity. | Minorities—United States—Ethnic identity. | Intersectionality (Sociology) | BISAC: SOCIAL SCIENCE / Gender Studies | SOCIAL SCIENCE / LGBTQ+ Studies / Bisexual Studies
Classification: LCC HQ77.9 .M97 2024 | DDC 306.76/808900973—dc23/eng/20231027
LC record available at https://lccn.loc.gov/2023047877

A British Cataloging-in-Publication record for this book is available from the British Library.

This collection copyright © 2024 by Rutgers, The State University of New Jersey
Individual chapters copyright © 2024 in the names of their authors
All rights reserved
No part of this book may be reproduced or utilized in any form or by any means, electronic or mechanical, or by any information storage and retrieval system, without written permission from the publisher. Please contact Rutgers University Press, 106 Somerset Street, New Brunswick, NJ 08901. The only exception to this prohibition is "fair use" as defined by U.S. copyright law.
References to internet websites (URLs) were accurate at the time of writing. Neither the author nor Rutgers University Press is responsible for URLs that may have expired or changed since the manuscript was prepared.

♾ The paper used in this publication meets the requirements of the American National Standard for Information Sciences—Permanence of Paper for Printed Library Materials, ANSI Z39.48-1992.

rutgersuniversitypress.org

Contents

	Series Foreword E. G. CRICHTON	ix
	Introduction: Your Race Is Your Gender STEPHANIE HSU AND KA-MAN TSE	1
1.	Outside In: Scattered at the Edge, Part One ARI SOLOMON	9
2.	What Flows through Me IGNACIO G HUTÍA XEITI RIVERA	31
3.	Jonas and the Flowers JONAS ST. JUSTE	45
4.	What Is a Pussy Anyway? S. L. CLARK	65
5.	Outside In: Scattered at the Edge, Part Two ARI SOLOMON	81
	Epilogue: Androgyny and Other Forms of Nonbinary Race STEPHANIE HSU	105
	Notes on Contributors	129

Series Foreword

Q+ Public is a series of small, thematic books in which scholars, artists, community leaders, activists, writers, and independent thinkers engage in critical reflection on contemporary LGBTQ+ political, social, and cultural issues.

Q+ Public is about elevating the challenges of thinking about gender, sex, and sexuality across complex and diverse identities to offer a forum for public dialogue.

Q+ Public is an outgrowth, after a long hibernation, of *OUT/LOOK Lesbian and Gay Quarterly*, a pioneering political and cultural journal that sparked intense national debate over the five years it was published, from 1988 to 1992. As an early (and incomplete) model of intersectional inclusion, *OUT/LOOK* was the first publication since the early 1970s to bring together lesbians and gay men after years of separate movements. The visual and written content of *OUT/LOOK* addressed complex gender roles (with a blind spot about transgender issues), was racially diverse, embraced political and cultural topics that were controversial or had not yet been articulated, and emphasized visual art along with scholarly and creative writing. In a period when LGBTQ studies and queer theory were coalescing but not yet established, *OUT/LOOK* built a bridge between academic inquiry and the broader community.

The Q+ Public book series was initially conceived by E. G. Crichton and Jeffrey Escoffier, two of the six founders of *OUT/LOOK*. They brought together a diverse and highly qualified editorial collective. The plan is to issue several books a year in which engaged research, art, and critical reflection address difficult and challenging topics.

The idea of a complicated and radical queer public has long been part of the vision and writing of Jeffrey Escoffier. Sadly, Jeffrey died unexpectedly in May 2022 at age seventy-nine, leaving behind Q+ Public as well as several other publishing projects. Prolific and full of ideas and vision to the end, he is widely missed. The Q+ Public collective continues this work in his honor.

Each book in the Q+ Public series finds a way to dive into the deep nuances and discomforts of a topic. Each book features multiple points of view, strong art, and a strong editorial concept.

My Race Is My Gender: Portraits of Nonbinary People of Color excavates the ways that race and gender—two socially constructed identity formations—become inscribed on the body through the journeys of the artists and activists contributing to this important collection. The writing is personal, poignant, and often poetic. *My Race Is My Gender* brings together a group of nonbinary and trans masculine people of color (too often ignored or tokenized in LGBTQIA+ groups, media, and academia) and celebrates their written narratives with striking photographic portraits.

E. G. Crichton

My Race Is My Gender

Introduction

Your Race Is Your Gender

STEPHANIE HSU AND KA-MAN TSE

Your race is your gender. At a gut level, that's the meaning of intersectionality, which is a Black feminist theory about identity at the nexus of interlocking oppressions. Nonbinary people of color experience this as an immediate truth because race and gender tend to be perceived and judged in the same instant based on the shapes, sounds, textures, gestures, and colors that we embody, in concert with other forms of identity we are taught to notice and respect or police. The danger of misrecognition, with its potential to feed prejudice and spark phobia, is the daily social violence that the nonbinary gender movement aims to confront. Although nonbinary identity and culture are mainly associated with resistance to woman/man and trans/cis definitions and divisions, the collaborators behind this book are joined by the following questions: What do our race and ethnicity teach us about nonbinary living? What can gender freedom mean in a racist and specifically anti-Black world? In a time

when intersectionality is increasingly used as a synonym for diversity or inclusion, the perspectives in this book revive our perception of the antiracist work that queerness (used here as a synonym for the nonbinary) does, or can do.[1]

The nonbinary gender movement emerged at the turn of the millennium, according to *Genderqueer: Voices from Beyond the Sexual Binary* (2002), one of the earliest collections of autobiographical writing by nonbinary contributors. Yet by 1990, *Living the Spirit: A Gay American Indian Anthology* (1988) had already been published, and the term "Two-Spirit" had been created by Native American and First Nations activists as an umbrella term to decolonize knowledge about Indigenous genders and sexualities and to replace the anthropological usage of Native words such as "berdache" for a third gender category.[2] The borderlands or "no-man's land" between Mexico and the United States had already been described as home to the queer, hybrid, gender-fluid figure of the new mestiza by Gloria Anzaldúa in *Borderlands/La Frontera* (1987). Asian American and Asian Canadian cultural workers had already criticized the Orientalist imagination for both desexualizing and hypersexualizing immigrants and refugees under the perpetual suspicion of their being terrorists, sex workers, or robots. The Middle Passage of the transatlantic slave trade had already been theorized as a site of the nonbinary where Black bodies became ungendered in their captivity, to paraphrase Hortense Spillers.[3] Without this grounding in antiracist and decolonial thought, the nonbinary movement for gender self-determination can indeed seem only two decades old and a millennial trend for "snowflakes" and saviors rather than what Black feminists call an act of worldmaking.[4] Embracing this antiracist and decolonial heritage,

however, means there's no liberation from gender binaries until racist binaries are dismantled.

My Race Is My Gender grows the library of life writing in nonbinary practice and theory by centering the perspectives of people of color. What follows are personal stories accompanied by photographic portraits created by Ka-Man Tse and other images curated by the authors themselves that help us to visualize the daily rituals of recognition that nonbinary living demands.

"Outside In: Scattered at the Edge" is Ari Solomon's account of a nonbinary childhood and young adulthood shaped by kinship bonds—lost, found, refused, and chosen— and forged in resistance to anti-Blackness in the foster care system and its disciplining of assigned female at birth (AFAB) bodies (Part One); anti-Blackness in the cosmopolitan or self-styled progressive social spaces that claim to respect their nonbinary gender identity and queer polyamorous sexuality; and the romantic relationships that do so when it counts (Part Two).

In "What Flows through Me," Ignacio G Hutía Xeiti Rivera draws on Black, Boricua, and Taíno history and cultural memory as sources of gender fluid identity, and water becomes the source of their connection to ancestors across, under, and through the Caribbean Sea and Atlantic Ocean. A grandparent now themself, Ignacio reflects on the daily and systemic violence they have survived as a trans-entity and gender-nonconforming person of color, and they teach us both how to fight and how to heal from colonized ideas about gender, Blackness, and Indigeneity that magnify the violence of binary thinking.

"Jonas and the Flowers" is a chapter of poetry and photography by Jonas St. Juste about the colors, shapes, and

other sensualities of being a second-generation Caribbean American demi-male, a cyborg with a camera, *oankali* (a shape-shifting species that Octavia Butler fans will know), a college exile rather than dropout, and depressed. In this collage composed of dating app messages, email correspondence with xyr former university, and snapshots of life under quarantine, Jonas sheds social and sexual roles that were never designed for xem and urges us to dream instead of real belonging.

In "What Is a Pussy Anyway?" S. L. Clark poses a question that comes to mind after being repeatedly misgendered in queer spaces from the LGBTQ+ community health clinic to drag karaoke. Like their own birthname, however, Black womanhood is a personal inheritance—not to mention a gift to radical politics and an inspiration to drag culture—from which they've never wanted to dissociate, and so their loving homage to Black women forebears ends with a love letter or poem to their own queer trans nonbinary Black self.

In the epilogue, "Androgyny and Other Forms of Nonbinary Race," Stephanie Hsu finds nonbinary insight in unexpected sources of critical race theory and queer and trans literature, as read by an Asian American androgyne. What emerges from this meditation on East/West, white/Black, and the spectrum of brown is the concept of nonbinary race, which is neither neo-colorblindness nor a state of being post-race. Rather, nonbinary race insists on a Black/non-Black binary—for how can we deconstruct a binary if we don't first admit its existence?—and corresponds to the multiform and nuanced practices of racial solidarity that nonbinary people of color invite and invent in the world every day.

Working with each of the writers to build their portraits, Ka-Man first read their chapter and then discussed the

different ways they could make a picture together, asking each writer to choose a space significant to them. These conversations and interviews as well as mental imaging, active listening, and ongoing dialogue and collaboration are all important to Ka-Man's process. The theme that emerged from talking to everyone was the importance of being seen. In a culture and an economy where speed and efficiency are valued above all else, a medium format and 4×5 film camera allow the photographer and subject to slow time and build an image together slowly. With Jonas, we went on a long hike along the Hudson River where xyr poetry and photography are often made. For S. L. Clark, we had two portrait sessions: one while they were doing drag trivia night at a neighborhood bar, and a second time at Brooklyn College, which has significance for them because it was where their aunt worked. With Ignacio, we drove down to Baltimore and spent the day with them in their home (after negative COVID-19 test results all around). For Ari, we spent the day together in their relatively new home they had moved into, and the stuffed animals in the portrait each have a story and carry place and meaning.

It has been an honor for us to live with our contributors' words and images for a time, and now we hope that this book is in your pocket—or maybe on a school library shelf, as Ari said to us, where years ago it could have proven to their antagonizers that nonbinary people are real, and they can be people of color, too. As coeditors who are both queer children of the Chinese diaspora, with full-time employment in U.S. higher education where Asians are overrepresented, we are developing our own styles of deimperialization in actual and imagined kinship with Hong Kong and Taiwan, prepared by our understanding of global anti-Blackness to be wary of future racial or ethnic supremacies on the horizon.[5] We have

tried to frame these chapters and then move to the margins in order to center Black voices, but that doesn't minimize us personally, because all of us in this book belong to the global majority. When it came to our coeditor portrait, however, Ka-Man's desire and creative instinct led us back to a site we'd both been avoiding, the New York City subway system, given the increased and often sensationalized news of anti-Asian violence since the pandemic. Ka-Man's process, as you know, takes time—the time needed to turn a space into your own place—and so we asked Jonas to make this portrait of us on the train platform, surrounded by the form of tracks that have carried the destinies of our people across continents, waiting to relive every journey ever taken for community. See you there.

Notes

1. Jennifer C. Nash, *Black Feminism Reimagined: After Intersectionality* (Durham, NC: Duke University Press, 2019), 6–12. As examples of foundational texts, see the Combahee River Collective Statement of 1977 (https://www.loc.gov/item/lcwaN0028151); Audre Lorde, *Sister Outsider* (Trumansburg, NY: Crossing, 1984); and Kimberlé Crenshaw, "Demarginalizing the Intersection of Race and Sex," *University of Chicago Legal Forum* 1989, no. 1, art. 8.
2. Qwo-Li Driskill, Daniel Heath Justice, Deborah Miranda, and Lisa Tatonetti, eds., *Sovereign Erotics: A Collection of Two-Spirit Literature* (Tucson: University of Arizona Press, 2011), 5.
3. Hortense J. Spillers, "Mama's Baby, Papa's Maybe: An American Grammar Book," in *Black, White, and in Color: Essays on American Literature and Culture* (Chicago: University of Chicago Press, 2003), 203–229.

4. Micah Rajunov and Scott Duane, eds., *Nonbinary Memoirs of Gender and Identity* (New York: Columbia University Press, 2019), xxiv.
5. Kuan-Hsing Chen, *Asia as Method: Toward Deimperialization* (Durham, NC: Duke University Press, 2010). See also Wen Liu, "Complicity and Resistance: Asian American Body Politics in Black Lives Matter," *Journal of Asian American Studies* 21, no. 3 (2018): 421–451.

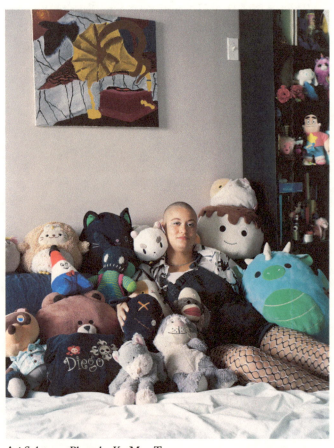

Ari Solomon. Photo by Ka-Man Tse.

1

Outside In

Scattered at the Edge, Part One

ARI SOLOMON

As a human, I am destined to repeat the cycle of unlearning and reeducation. In the tradition of white patriarchy, enslaved persons and Indigenous communities on this stolen land were violently force-fed a false narrative about the infallibility of white-centered education systems, media, and government that inevitably made its way across the generations to me. The pledge of allegiance and salute to the flag continue to be an introductory tool of the brainwashing ceremony that teachers include in their daily routine. The exchange of participation in displays of patriotism, no matter how small or extreme, for the fragile guarantee of the "American Dream." While some young students head into school with a blank slate for their country of residence, I headed into school with this nation having revealed its ugly nature in predetermining the hurdles of my life and those of the people around me. I hit the first hurdle on the day the police entered the Californian motel at which my white,

Indigenous birth mother and Black, Indigenous father were residing with my brother and me.

The memories come to me in fragments scattered across emotions that continue to remain with me. Two small, hurriedly dressed children with frazzled, uncombed hair being ushered into the back of a police car as though we inherently bore criminal intent will forever be ingrained in my memory. Not a case worker on site to hold our hands and offer a stuffed toy. No soothing words. No hugs. Only the physical embodiment of THE LAW in the form of loud, quick-tongued officers and a cold police car, whose back seat felt so large in comparison to our small bodies. Whatever illusion of normality I had at the time was shattered. I was left with the overwhelming knowledge that my existence was an inconvenience and thus solely a problem to be resolved. I laugh now at my accurate impression, as police officers have a long historical record of being contracted by the U.S. government for the removal of "inconveniences" by any means necessary. The inconvenient existence of nonwhites, born of the white mind and legislatively solidified by the one-drop rule, was and continues to be the reoccurring militant plot of U.S. history.

When I think of the day the officers barged into my life, I know their actions and decisions were framed by the actions of white colonialists hundreds of years prior to that date. My brother and I were classified as bereft of humanity and innocence due to our skin, background, and lack of finances, making us solely an inconvenience to these officers. They could not fathom speaking to us as children because, according to them, we were incapable of telling our story or even holding a light, distracting conversation. Now, being an inconvenience does not exclude the possibility of entertainment at our expense. Hell, if anything, our pitiful situation

seemed to make it all the more fun for our temporary babysitters. The officers showed no hesitation in adding to our mountain of trauma as though the crumbling mental state of my brother and me were a hi-score game. With minds clouded by confusion and fear, my brother (a year younger) and I were led through the holding area of the jail. With an officer ahead of us and behind us, our virginal eyes faced the truth of our society as we struggled to comprehend the immediate present and predict the very near future.

Unfortunately for my brother and me, but true to the cruelty of the foster care system in the 1990s and early 2000s, we were traded from home to home over several years, totaling nine for myself and ten (including a group home) for my brother. As a four-year-old with a three-year-old brother, we knew that finding a permanent home would be our best attempt at reestablishing normalcy. But no one had shared the rules of the game with us. I don't remember the first home or even the second, but I know that we were never meant to stay long. Between the foster parents and schools, we were plagued with the thought that there was no place for us. The American Dream of the white mother, father, 2.5 kids, and a family pet was as distant as ever, since where did the "mixed" (that is what they called us then) foster children with a murky background and foreseeable emotional instability fit in this picture? The foster families seemed to be preset by the time my brother and I were dropped off with our belongings in a trash bag. With the illusion shattered before the lies had even been fed to us, patriotism was never going to flourish in my heart. I realized when the American Dream was being discussed at any level to take the conversation with a grain of salt because it was never meant to include people like me. We were not part of the conversation, and fighting our way into it left us with targets on our backs. With no one

to fall back on, my brother and I formed an unspoken alliance with the goal of surviving together while learning as much about ourselves as possible. It was us against those who had the power to change our lives with the dial of a phone.

Consumed with piecing together the puzzle of "Who are we?" we clung to any information that came our way. Whether listening secretly to the social worker who met every so often with our current foster parent or to information told directly to us, we held these words close to our hearts. I filled the blank pages of my narrative with these glimmers of identity without stopping to separate out the ones that were meant to denigrate and undermine the pillars of my selfhood. The steady fashion in which the details dripped informed me that it was not I who controlled my narrative. By the time these morsels reached me, they had passed through many hands that would never touch mine. It was they who had the status, ability, and money to access and amend the records of my brother and me. Each meeting with the social worker, new home, or school registration included the file containing my placements, behavioral incidents, and health records. This narrative, developed by the authors, served the bureaucratic requirements of the foster care agency but ignored and invalidated my human experiences.

One specific experience of invalidation had to do with a small pet tropical bird and a toy pickup truck. Being a small child, the division between reality and cartoons had not yet been set. Excited by the bird's pretty colors, I decided to give the bird an opportunity to drive the truck, as I had just seen on television. Of course, this was not a choice I would ever make now as an adult, but as a child I went ahead, assuming that the cognitive ability of the bird was the same as my own, perhaps better. It was not long before the bird was set to make its scheduled pickups and drop-offs that the owner, my foster

parent, walked into the room. The screaming, the handwaving, and the snatching of the poor bird from my hands haunts me still. The bird was taken and placed in its cage outside overnight in 40–50°F weather. The next morning, the bird was dead, and I declared a murderer—nay, a psychopath. Pocketing away this new detail as a descriptor of myself, I nodded as my foster parent screeched that I had no emotions and needed to be stopped. It wasn't until later as an adult, with the help of therapists and caring individuals, that I realized the bird's death had everything to do with it being left out in the elements overnight. The adults around me, looking for someone to blame, ensured that my permanent record would highlight this event. Whenever the incident was brought up, it was usually due to an adult attempting to justify their abusive actions toward me so they could reclassify them as a just punishment. "See! This child is a murderer! Of course, we need to punish harshly." My counters and contestations were futile without the validity of whiteness and assigned maleness or, hell, even an adult who was on my side. Even though this addition to my self-image was a new acquisition, the hunger growing inside me to know who I was weathered me down until I accepted anything I was told, whether of a positive nature or negative.

So quick were adults to toss labels at me in an effort to answer what rather than who that I, without knowledge of the distinction between what and who, was ever eager to consume these clues. With my outer appearance and behavior serving often as the topic of conversation when I was around, adults' favorite descriptors for me were "wild child" and the then-popular "bebes kid," who needed to be tamed along with their hair. The manner of taming would change from home to home, but it almost always started with taming the tangible factors of my being. Rather than

talk to me, my foster parent would decide on a series of quick fixes, always visual and skin-deep. The list of steps in taming the recently arrived inconvenience would always start with "HAIR." Naming the offending problem allowed my foster parent to begin the process of taming me. "BAD," "KINKY," "NAPPY," and "TOO MUCH WORK" were only some of the words used to describe and categorize the natural fibers of my being pushed through my scalp. Knowing more ways to negatively describe hair than I did positively reinforced the inconvenient nature of my existence more than any broken brush or comb ever could. This reinforcement existed in the backdrop of society, from hair care products to TV shows, but none hit so hard as the moments my hair became an issue ahead of social worker visits or public church events to be attended. It was then that I was told to sit still while the foster parent went to town parting my hair, the sharp edge of the parting comb dragging against my scalp. My brother was never too far away as they loudly complained about my hair being difficult and a mess. Embarrassed and ashamed, I would focus on staying still as my head was yanked around by my wild, untamed hair and as each foster parent used different techniques to tame it, with the most consistent being braids, pink lotion, and gel.

I believe it was one holiday or another that had prompted my first encounter with the hot comb. One by one the AFAB (assigned female at birth) curly haired foster children of the house took their place in the kitchen chair by the stove. I took note of the absence of the AMAB (assigned male at birth) children, and then my turn arrived. As I sat in the chair confused, I wondered why someone wanted to waste their time and energy on hair that caused so much grief. Invoking whoever gave a damn, I kept my head steady, inhaling the relaxing smell of moisturizer, oils, and burnt hair—soon to be my

hair, as it was separated into manageable sections while the comb heated on the electric hot plate. Casting out of my mind the phantom squeals and teeth-sucking of the chair's recent occupants, I balanced my focus on not moving one centimeter while committing to experience the joy of being cared for, even by an emotionally distant foster parent. Since someone forgot to warn me that not moving was the same as moving, I was yanked by a section of hair and subsequently burned in several places, causing me to squirm even more. It is damn near impossible to remain still when someone burns you with a hot comb. Unfortunately for my scalp, I was going to feel the pain for several hours. When this bittersweet, painful ordeal was over, an air of approval came from my foster parent. Misinterpreting their approval as being for myself, my mind was overrun with questions. Was that all I needed to do to receive a glimmer of love and validation? Hot comb my hair? Have "easy" hair like the kids who didn't look like me? If I gave up a fragment of myself to be edited and carved by those who were in charge of my care, would the days become easier and filled with familial love? That microsecond of approval left me with anticipation for my next turn in the seat and a strong desire to maintain my new hair texture by taking care not to get it wet and wearing a tight head wrap each night to sleep, hoping that I could experience that glimpse of approval once more.

Revealed to me over time, the hot comb was only one of the tools used to increase the palatability of my existence, specifically to the occasional white person and the questioning gaze of the congregation of whatever church we happened to be attending. Yes, there were nosy church members who wished to gain insight into the lives of the other attendees, but that was to be expected, especially since we and some of the other foster children lacked visible resemblance

to our foster parent. The proper presentation of children was held in high regard at every church I went to, whether it was Baptist, Christian, Catholic, Pentecostal or Seventh-Day Adventist. The "boys" would wear anything from button-down collared shirts with creased black pants to cargo shorts and a dino t-shirt, while the "girls" wore dresses with stockings and hair that showcased the "loving" effort that had been made. Straightened hair, dresses, itchy stockings, and ridiculously frilly socks were expected for events where adults would acknowledge and subtly criticize each other's public image if a single hair was out of place. Any ill-fitting clothing from previous foster children was repurposed for new foster children, reconfirming my understanding that nothing could be truly ours, not even our bodies.

As a ward of the state in the foster care system, my body was under the control of the State of California. The agency and visibility that I see highlighted today in discussions regarding childrearing was unknown to me as a child. I had no ownership or control over myself or my future nor that of my brother. It was only my defiance and reactive behavior to being cornered that kept me alive physically, mentally, and emotionally. Sometimes I was successful in achieving my momentary release of pent-up frustration and anger, but the swift consequences intended to put me in my place of blind obedience were never too far behind. Whether the consequences were outright beatings or unplanned displays of authority and power, the psychological impact was lasting. Wetting the bed warranted being backed into a corner with a jarred spider shoved into my face with the threat of it being released on either my brother or me. Lying led to being hit wherever I was most tender and easiest to seize. Falling asleep in the car without being quick to stir led to the window being

rolled up with my hair caught in the frame and me left in the vehicle. Each time, I sensed a restrained enjoyment coming from my abuser, as if they had been looking forward to the release of their hatred onto me. So quick were foster parents to engage in abusing me that I hardly had time to question or wonder, with my focus being surviving. As an adult, I see the distinct difference in how I was treated versus so many of the other children whose lives briefly intersected with mine. There was this assumption that due to my status as a brown AFAB child sans adult allies, it would not be possible for me to reveal their actions, especially since my file was often weaponized as a form of confirmation to anyone that I could not be trusted. Wondering if everyone was treated this way, I studied the relationships of the foster parent with their biological children, their adopted children, and the other foster children.

As my brother and I were discussed in hushed tones, usually in the kitchen, our futures were often decided without us. As foster parents adopted the fairer and younger children to bestow them with a family name, we were passed around like an undercooked appetizer at Thanksgiving. Considered for a short while and passed along. Frustration became a familiar feeling as we repeated the cycle again and again. Foster parent becomes angry that we were not easy to manage, a new home is sourced, our items thrown into a black trash bag, the social worker shows up to tell us to say goodbye, and we are driven over to the new place, introduced, and left with our new warden. As we would unpack our few personal items from the last home, the rules of the household would then be rattled off with sly warnings of punishments and a sense of the inconvenience of our arrival. No one was ever excited to meet the new foster kid, let alone two. Unfortunately for my brother and me, our resurfacing hope of

arriving at a better home was consistently squashed by the immediate reminder that we would never be on the inside, though we were lucky to have each other. It felt as though I was outside on my tiptoes looking in over the windowsill. If I could just stand a little taller, then maybe I wouldn't leave each home fractured in my self-esteem and further indoctrinated into accepting the pre-selected societal roles.

The good thing about being a child is that even when you are in the midst of survival, fear, and anger, hope is never too far behind. Hoping for a way to break from these invisible divisions, I took notice of who was attaining the status of family. Across the nine different homes, I saw very few children who had crossed into such a status, usually as white babies. My last foster parent had adopted a white child, and even the gentle whispering tone used by the social worker and foster parent when talking about this precious baby was antithetical to the tone and body language used when it was my turn to be discussed. My skin color, my assigned gender at birth, my brother, my unhealed trauma-induced emotional "outbursts" and history of being born addicted to crack all served to exclude me from achieving my unspoken goal of family. Adding me to their family would cut against their hard work of cultivating an ideal family structure. Realizing that the possibility of adoption was beyond me, I began to believe what the other foster kids had been telling me for years across nine foster homes, that the dream of adoption by an adult who would take the time to know me, fight for me, and love my brother and me was dead.

As to be expected, my frustration with the lack of control, power, and love in my life was noticed at school. Quick to expel me and heavily document my actions, schools and foster parents weaponized paperwork time and time again when attempting to pass me on somewhere else. Each

expulsion and each meeting with our social worker ensured a healthy stack of forms containing accounts of fights, arguments, and defiance. Pointing at the page, their eyes would focus on me, demanding an answer. While they wanted answers for my behavior, I wanted, and still want, answers for why I was denied meals, why my clothing didn't fit, why we couldn't talk about being hit, why being threatened was acceptable, why I wasn't allowed to stick up for myself, why no one cared how I felt, or why it felt like my brother and I were singled out time and time again. What I unfortunately did not realize in time was that in our society, with me as a multi-racial-AFAB-gossipy-permanent-record-havin-quick-to-fight-angry-foster-child with behavior problems in Compton, California, we were two of thousands.

No child wants to have anything to do with the school principal, especially in Compton, where the police presence was both familiar and despised. Having had more interactions with authority figures than most, I noted the constant presence of my current principal. Stepping from the shadows, this principal engaged me in short conversations that thankfully never touched upon my behavior, at least not at first. Surprisingly, she was interested in what I liked to eat, my favorite colors, my birthday, home life, and more. If I was older, I would have accused her of stealing my identity, especially since it appeared that she had stolen my DNA. We looked so similar that staff on campus passionately believed that I was her child and began reporting my varying incidents to her. Starved for attention and food, I was easily enticed by her seemingly endless supply of buttery crackers. I spent more time with her, and any casual friendships I had with my peers began to dwindle as I alone entered a new territory. Unknown to me, my future was being decided and manipulated right under my nose, but I

was too busy consuming free snacks in the lap (and under the desk) of the principal. The fact that someone wanted to touch me without pulling back and seemed genuinely interested in who I was confused me. I would go home for the day only to return to her unwavering interest in me. Using our physical commonality and her position of authority, she sought to close the gap between us. The whole school knew before I did that she wanted me as her own child. I was claimed. Someone wanting to adopt me was my dream actualized after years of being the child forgotten and never considered. Opposing the years of being told and shown otherwise, someone was finally seeing that there was some worth to me. I had been shown that my presence and the concept of family could coexist in the same space.

When I heard the whispers about sending my brother and me to a group home, I fell deeper into the charismatic spell the principal spun with the illusions of love, family, food, and community. I became focused on my dream of my brother and me living together. Without consulting my only blood, I said yes to her, assuming that since we were always moved as a pair, we would be adopted together. Shortly thereafter, I was transferred to live with her—without my brother. Overwhelmed by the opportunity, I left my brother in the foster home with hope that he would soon follow. I wish I had fought harder for him to live with us, preventing his transfer to the group home where we both initially were to be transferred. I still kick myself about it to this day because it was as if I had left him to his struggle alone for the first time. Had I flapped my lips, maybe he could have avoided the loneliness, fear, and pain that I know plagued him during his stay. Forever a pair, we stood firm against whatever was thrown our way by foster parents, social

workers, foster children, teachers, and doctors. Now that we were split up, it was every child for themselves.

The first year of my adoption seemed placid on the surface. The thought of the brown problem child being reined in by the new, prospective, kindhearted adoptive parent seemed to put those around us at ease. The truth is that I was with someone who appeared as my parent but remained opaque about her parenting style. But as history has taught me, there is the written text and then there are the oral stories passed down and around communities. No one knew or cared to hear my story as a brown child recently adopted by a brown mother. The fact that we were together ensured that no one would bat an eye when I appeared at school the next day wearing long pants and a long-sleeved shirt, even when it was very hot, to hide the products of the abuse that had occurred the night prior. One of the earliest seizures of my personhood came when she restricted whom I was allowed to eat lunch with, since she didn't trust me not to act in an inappropriate manner. I question this request and tactic as an adult. If I was appealing to her while playing with friends prior to being adopted, why were my friends no longer acceptable? It's true that the topics of our unmonitored conversations were not always pure, but it was the bond between us that was key to our childhood. While talking about who was switching when they walked and playing hand games, our laughter bonded us together. In an effort to mold and set the pace for my social development, she deemed this sort of behavior ghetto and beneath the status that my future adoptive mother seemed eager to attain. I realize today that we both had the same goal of not making waves in a world structured to disenfranchise and profit from Black and Indigenous folks. The only difference was that she was focused on maintaining our public appearance as an unassuming,

nonviolent, civilized family, while I was focused on securing safety, food, family, and love.

The time came for the inevitable visit to the doctor with the crowded waiting room. Taking the opportunity to finish some homework (as if I could do anything else while under a certain watchful eye) among the other waiting patients, I was aware of the invisible chain between my adoptive parent and me. As other kids played and chatted with one another, I silently sat in my chair waiting to be called. After a series of tests and questions from the doctor, we returned home, and within a few days, I was taking a new medication. This cycle repeated itself so often that I truly believed that something was wrong with me. Fearful of doctors, I stayed silent and went along with the medical-professional-verified-request to medicate me. I hoped in vain that the medication would dispel the catalysts of her frustrated outbursts. Unforeseen by me, the issues between us increased, and my will to fight back dissipated in the fog of my heavily medicated day-to-day along with the belief that I would ever be enough.

Around the time I was officially adopted, my daily life was predictable but highly regimented. With even less privacy than most kids because the principal of my school was my guardian, there was nowhere I could freely exist. From students to teachers to cafeteria staff, all eyes were on me. I waited with bated breath until the end of each day to gather how my actions would be misconstrued at the end of the day. Dropping a pencil and ducking down to retrieve it during class was sure to receive a lecture that always seemed to end just as we were stepping in the front door. My actions would be listed out along with the often-repeated line, "How do you think this makes ME look?" My actions did not befit the status of a multi-racial Black mother leader seeking to create

vast change and improvements within the L.A. public education system. When I said "ain't," I made her seem uneducated and incapable of teaching. When I turned cartwheels for fun, she thought onlookers would be quick to critique her ability to assimilate me into my predetermined gender role within the stereotypical family structure. If her own adopted child acted out of turn daily, how could she succeed at fulfilling her role as a working single parent? It was as though any gains she had made in this white-centered and male-led society were being erased by my behavior and existence. When the physically violent punishments proved insufficient, the Bible was literally thrown at me. For hours on end, I was locked in my room with this book that had been explained to me as a guide for being a better person with the instructions to focus my attention on nothing else, even desperately required sleep. As I read page by page, I became increasingly confused by the stories. If this was a guide on how to be a better person, how was it that so many people went out of their way to hurt me or display their authority over me while also having access to this guidebook? Shortly after my introduction to the Bible, I was baptized without my consent. I accepted my circumstances and proceeded with the baptism even though I had some concerns. If I protested, I was sure to draw the ire of my guardian.

It was around this time that I was enrolled in a private Catholic school. Putting two and two together, it made sense that I needed to be baptized to attend the school. When I arrived, I was completely out of my comfort zone. Surrounded by children who were used to having their needs and questions met, I stuck out like a sore thumb. With every teacher knowledgeable of my entire history including sexual abuse, I hoped to hide behind books. The library opened to me worlds upon worlds as well as the door to being bullied.

I much preferred the books of women and girls telling stories from their own experiences. It felt as though I could really know the world of the author or narrator. As I consumed as many books as possible, the other children noticed that I was not like them. I wore a skirt and sat with my legs spread while ignoring bench gossip in favor of the next novel in a series. I seemed to know the answer in class or have my own questions more often than was deemed appropriate by my classmates. As children do when they happen upon someone different, they made me the center of their ridicule and harassment.

The first time I heard the distinctive and othering terms "zebra" and "oreo" was from the mouths of my classmates at a Catholic private school. The moral compass of the Bible held no weight on the unforgiving pavement of the playground. These words as well as others were quick to escape the lips of the other students should I breathe out of cadence. Nothing I did was good enough for them, and I should have known that, considering life at home. I was a multiracial child whose understanding of feminine gender presentation was skewed due to focusing on surviving rather than passing. Beyond the harassment at school for being uninformed and uninterested in the typical rites and displays of femininity, my biggest bully lived in my home. I was overmedicated, used as a household servant, and denied basic support when my body began to change. Terrified, I refused to broach the topic as the changes chiseled away, leaving me to feel increasingly unsettled. Instead of a conversation, I received a book, *The Care and Keeping of You* by Valorie Lee Schaefer, but not in time. The supportive and soothing language of Valorie was no match for the cold and caustic approach of my adoptive parent, and even the illustrations of razors, pads, and bras all served as reminders of

what was due to me but denied. As my body changed, hair started sprouting up and my chest size started increasing. I was well aware that I had no one to confide in. I tried deodorant for the first time at a babysitter's home. The label read as though it would remove the hair under my arms, for which I received constant grief from my peers. Excited, I applied the tube secretly in the bathroom only for a searing pain to cause me to grab soap and quickly scrub the product off. The whole time, I hoped that no one would find out, as I knew it would get pipelined directly to my warden at home.

Silently noticing these changes, my adoptive mother decided to hide them by requiring that I wear gymnastic leotards underneath my clothing to maintain a childlike shape. These leotards were purchased for me during the first year of the adoption process and were several sizes too small. However, the fear of being caught without them on pushed me to ignore the straps biting into my flesh on my shoulders and pelvis with each step I took. With no one to consult for fear of it reaching back to my adoptive parent, I endured the pain and spoke to no one. My body was not mine, and there wasn't anyone to say otherwise; the isolation was magnified by the pain surrounding my ribcage. I mentally repeated the circumstances of my life as I subjected myself to the unannounced checks to see if I was wearing the required garments. One night, the divide between my adoptive parent and me (physically and mentally) began to expand when I woke up with the worst nausea and stomach pain I had ever experienced. Not having eaten anything abnormal, as my daily meals were restricted to chicken nuggets, mac and cheese, and a vegetable, I confusedly tiptoed to the bathroom. After throwing up, my gut still gurgled, so I sat on the toilet only to realize that I had been hit with what that

book and many others had warned me of, my first blood. Mourning my previous physical state and experiencing crippling pain, I fell asleep on the bathroom floor wishing that the fairy godmother from *Cinderella* (the Brandy one) would hold my hand, speaking promises of comfort. Reality rudely woke me with my adoptive mother staring down at me with disgust. Struggling with my fear as I explained what happened, I was met with a glare. Some pads were unceremoniously dumped into my hands with no instructions. Thankfully, I had internalized some of the information from the book my adopted grandmother had given me, so I was not wholly unprepared. With nothing but books to inform me about my body, I relied on the limited knowledge of people I would never meet to move through these changes.

When the day felt as though the world had shouted, "You have no place here. Disappear, you inconvenience!" books welcomed me at my own pace as a silent observer of the world held in my hands and painted in my mind. It was from books that I gathered the knowledge needed to get to where I am today. Not always understanding what I was reading, I did not let my stunted social skills block the book's imprint left upon my personhood. I saw the world through the eyes of hundreds of people, real and imaginative. It was not the celebratory instances that stayed with me but how the characters persevered during times of immeasurable pain and obstacles. Diaries of young Black girls who learned to read and write in secret while enslaved emboldened me to read library books by moonlight when all my books were taken off the shelves in my room and hidden from me. *The Color Purple* gave me the language I needed to recognize and discuss abuse. Journals kept by Indigenous children stolen away to Indian Residential Schools inspired my desire to secretly secure the strongest, though smallest, grip on my

identity. My encyclopedia had sections that detailed the history of the United States and warned me not to swallow the story given to me by history textbooks.

Sometimes even having the knowledge at my fingertips was not enough when I failed to factor in the authoritative forces within the home. A major change that I was unprepared for was the odor and sweat clinging to my skin and clothes. I had lived so long with a body that I had grown to like that these physical changes were overwhelming and left me feeling wholly unprepared. When my adoptive parent noticed the body odor before I did, she decided to utilize it as a lesson in authority and self-esteem by denying me showers for multiple days. This unhelpful and abusive parenting style caused me increased heartache as fellow classmates would point out my state of disrepair and alerted me that I was assaulting their olfactory senses. When I walked around at home, I was reminded that I stunk and how disgusting I was sprinkled with spiteful laughter. Even her wedded husband who refused to legally adopt me joined in her physical and verbal chastisement. When my acne took a downward turn, further ostracizing me from any promise of friendship, it was as if nothing was going right with my body. My chest hurt from the tight leotards, and I had more pimples than I could count, branding me as the four-eyed, pizza-faced monster at school.

It wasn't until one summer when I had been publicly declared too difficult by my adoptive parent that I was sent away to visit my great-grandmother in New York City. It was there that I learned the power of informed choice. From clothing to what we ate for dinner, my great-grandmother gave me a sense of individuality through the freedom she entrusted me with. Initially I was wary of her due to the limited times I had met her as well as her loud silence

during the years of abuse. She was a white woman who showed me greater respect than the woman who adopted me due to our racial likeness, and I opened up to her in a way that I had never done before. When she saw the leotards I was required to wear, she shook her head, acknowledging my pain, and said there was no need for me to wear them. Immediately, she got on the phone with my aunt in Brooklyn, and next thing I knew, we were going bra shopping. I was over the moon! I hated running (another favorite punishment of my adoptive parent) while my chest growths flopped painfully around. On that same day, I was brought to several stores to get the items I needed for my changing body. I am forever grateful for that moment because until that point, clothing was provided but never offered. The power of choice was in the hands of my adoptive parent, who utilized clothing to add to the illusion of a stable household. While traveling between stores, I was asked about my other routines so that I would have all I needed to take care of myself during my stay. I found out about other types of deodorants for folks whose bodies are a little too efficient at expelling sweat.

Even my hair routine was queried and supported, especially after they learned that my hair had been punitively and severely cut against my will. My great-grandma deferred to my aunt on this because just like my adoptive parent, her sister, she was closer to understanding my hair texture. So, my great-grandmother stepped back and allowed my aunt to educate me on my hair, even mentioning products used specifically for curly hair. Until then, I was only familiar with Suave or Alberto Vo5 because those were the choices provided. I had never seen my hair with curls on curls on curls, so it was easy to trust them in other areas of hygiene. They knew when to step forward and step back based on the help

that they could offer. My great-grandmother did not know anything regarding shaving legs and armpits, so she stepped back and asked my aunt to show me how to properly shave. I was eagerly attentive, as my hair was often an issue to other students. Knowing how to shave my legs and armpits took targets off my back. Knowing how to style and manage my hair helped me protect myself from the ridicule of the other students, although they still threw trash and random objects into my hair as a game. Even my acne improved during this time, although I would include decreased stress levels as a factor. I returned to California with a sense of dread. I had tasted bodily and mental autonomy. There was no way that I was going to ignore that experience and shrink myself back to the small sense of self that I had clung to all those years.

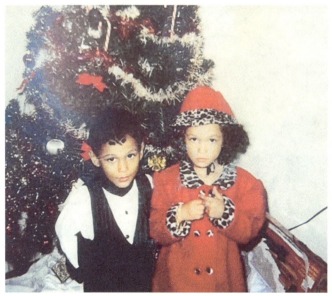

Ari and their brother. Photo courtesy of Ari Solomon.

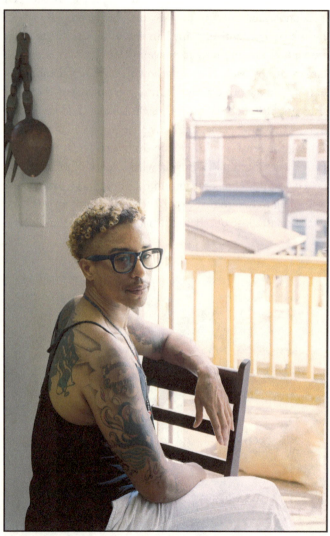

Ignacio G Hutía Xeiti Rivera. Photo by Ka-Man Tse.

2

What Flows through Me

IGNACIO G HUTÍA XEITI RIVERA

Conduit

I contemplate as many possible comebacks as I can fathom to actual and feared street interactions. I stand in front of the mirror mouthing the words I could possibly say if all the variables were in place. I try on sarcasm, laughter, denial, flight, and kindness. I can never be sure what moods are circulating in the atmosphere, waiting to land. My otherness acts as a brightly lit landing strip. This is the inevitable collision I train for. The skid marks have almost faded since the last crash landing. I wasn't alert enough that day. A group of four or five teenage girls, ages sixteen to nineteen, followed the blurriness of my lights. They followed me for several blocks, taunting, cursing, and threatening. They were so loud and angry. They were enraged by my ambiguity. Mayday! Mayday! I could do nothing. In this situation, I felt I had no choice but to take it. If I defended myself, it very well may have been deciphered wrong. A spectacle of a freak or a man,

fighting with some harmless girls. I didn't chance it, and eventually, the roar of our collision faded in the wind.

I'm pondering the most probable interactions I could have today, considering that I feel strong enough to take a walk with my daughter and grandson. It's a beautiful day out, and I have decided to wear a flowing cotton dress. The neighborhood is vibrant with music, laughing children, blaring cars, and yapping dogs. I'm afraid that when I exit my house, all the possible interactions I might face will be exacerbated by the onlooking crowd. Crowds used to be a source of safety for me—when seen as a cis woman. In public, people generally don't like to see explicit violence or disrespect against women. I can't expect them to intervene on my behalf anymore—not as a "gay man" wearing a dress, not as a trans person wearing a dress, and not as whatever nonconforming outsider they deem deserving of rejection. Today, crowds are a source of uncertainty and chaos. After much rehearsing and consideration, I decided to change.

Who or what am I today? A daily contemplation of external and internal factors that have significant effects on my comfort and my mental and physical safety. I gauge. I'd love for my desires of expression to win, but having ease and decreasing anxiety wins most days. Today, I chose an approach that could save me, but it depends. There is a privilege in the ability to choose and "alternate," and likewise a curse. Who or what am I today? It depends. What I desire is a mere portion of the equation being written and rewritten in my mind's eye. I try to find the right calculations for the best outcome. I hope.

I'm what you might call confusing or weird. I've been referred to as exotic and disgusting. It depends on the day, state, city, or neighborhood. In some way, shape, or form, I have always inspired questions. People have a need or even a

compulsion to know. Meeting me for the first time, passing me by on the street, providing a service for me, or just being an all-out-stranger requires me to explain. Explain some nicer, cleaner, understandable, unconfusing way of me existing in the world. My response to their question is often the proverbial record scratch. I'd answer, then wait to see if the needle played the sounds again of rhythmless taunts, accompanied by the potentially unchoreographed "dance of the attack."

I rehearse. In front of the mirror or quietly in my head. I flunk at swift comebacks, so practicing is unquestionably a requirement. Most days, the-rapid-response ideas slowly appear several hours later as I'm nodding off. "That's what I should have said!" I say all too often, too late. A response like that, in retrospect, is an indication of a "mild" encounter. In most interactions, I don't have time to come back to a desired response because none is needed. At that moment, I'm more concerned with how to get out of the situation itself—immediately! In those circumstances, I disconnect eye contact; I engage with another person or persons; I walk away fast; I duck, bob, and weave out of sight; and I run.

Where am I going? Who will I see? Do I know these people? Are they queer? Are they people of color? How long will I be staying? Am I driving, taking a car, or taking public transportation? Is this a work-related space or personal? Will I be around people in altered states? This experience is not new. Many women have experienced contemplating an outfit and its possible interpretive impacts. Our better wisdom reveals to us that regardless of what you have or don't have on, nobody has the right to violate you. Yet, there are systemic contradictions. The threat of violence isn't new for me; it has just shifted. When I was a girl, a young woman, and a thirty-something-year-old, I was on display for the

male gaze, their penetrating words and unwanted touches. As a trans-identified person of fluid gender, those daily sexually focused intrusions were somewhat replaced by testosteronic aggression. Rather than the instinctiveness of boys and men to take and fuck my body, it was that they instead wanted to physically hurt or kill me.

Who or what am I today? It depends. I'm a person assigned female at birth. Around fourteen years ago, I came out as trans—a trans-entity, to be exact. My partner at the time came up with the term to best describe our gender identities. We didn't identify as men. We honored our female experiences and believed our current bodies were but a vessel to carry our essence. I knew that I was more than the limited female marker on my birth certificate. The first eight years of my gender journey, I identified as a no-op, no-ho trans person—no operation and no hormones. I experienced my gender as my own. It was for me to journey through. No surgery or hormone could tell me what I had already known, I was trans. My gender can always shift, evolve, and grow. I welcome it. Today, I've had top-surgery and I'm on a low dose of testosterone—a contemplated forced migration, enacted for safety—a survival surgery.

They get angrier when they're witnessed reacting. Mostly cis boys and men. A switch goes off. The process is swift and it's in chest-pounding, agonizing slow motion. I'd sense it before it began. I'd see the look that catches. The glance that propelled a double-take to make sure—of what, I don't know. Then, once he was sure and "it" was confirmed, the wrinkled nose and snarling eyes would follow. I'd retreat into myself. Try to become small or get out of there before anything happens. The squinted eyes of perplexity-turned-finger-pointer, yeller, and charger. Charging toward me with purpose and right—deserving an explanation.

Who or what am I today? It depends. I have little facial hair. Sometimes I wear it and other times I shave it off. I wear typical "unisex" clothing and on many occasions wear makeup, dresses, or skirts and use purses. My gender presentation is at the intersections of femininity, masculine physique, and obscurity. Rarely, but it does happen, I get read as a butch dyke. I assume people think I just have natural facial hair. They interact with me using "she" pronouns. Most often, I'm seen as a femme gay man, and most recently, I've been read as a trans woman. Butch dyke, femme gay man, and trans woman are all identities that teeter on the knee-jerk reaction scale from verbal harassment to physical harm, to murder. The ever-fragile toxic masculinity of cis men is angrily perplexed or shamefully enamored with us. Therefore, who I am or what I am depends on how the world sees me. Do they hate me? Do they think I'm a joke? Do they see me? Will they try to harm me? Will they try to kill me? Will they rape me?

These questions spark déjà vu. These daily, ever-looping contemplations of who or what I am stretch farther than the constraints of gender onto my race and culture. The colonized ideas of gender, Blackness, and Indigeneity, extensions of binary thinking. I wonder if my ancestors asked themselves the same thing. How they must have worked so hard to pretend. How they must have altered every part of their beings to survive. I wonder what questions they might have had: How should I speak? What should I wear? What places should I avoid? Who could be an ally? Who are those most likely to hurt or try to kill me? The living of our lives, threatening to the declared "norm," is reason enough for the masses to incite violence.

There is confusion sparked by power, held by ignorance, and validated by violence. That power maintains that *we* are

the so-called "confusers." We upset the balance. We outstretch the cookie-cutter's dulling edges, proving every day that there is more beyond the once-sharp border. We are not the perfectly shaped, one-flavored, easily identifiable cookies. There are so many more shapes, colors, tastes, and textures to experience. We were told that there was only one mold, but we are proving that wrong by our very existence.

Historical Yearnings

I am Black, Boricua, and Taíno identified. This lineup of identifiers is redundant, in my opinion. The Boricua identity is ample enough, but for some, it represents another way to say Puerto Rican, void of either the Native Arawak-Taíno side or the forced-migrated-enslaved-African side. This omission, sometimes rooted in miseducation, colorism, anti-Blackness, and/or the belief that our Native bloodline is extinct, contributes to a thematic trend of having to prove our realness and belonging to land and location. This mesh of colonized, enslaved, relocated, and presumably endangered blood and bone is the trajectory of my gender.

I think I've always felt somewhat different from my family of origin. There were five of us—my mother, father, brother, sister, and me—in that order. From the lot of us, I was the sole Nuyorican—a Puerto Rican New Yorker. Everyone else was born in Puerto Rico. My siblings often teased me, saying that I was the mailman's kid. Other times, they taunted me that I was found on a doorstep. I figured they were making it up, but sometimes I wondered. I think I sometimes fantasized I was from somewhere else. I thought it would help explain my queerness. I was bitter that I couldn't proudly proclaim that I was a "real" Boricua. Nonetheless, I grew proud of my Puerto Rican and "pseudo" Boricua identity.

The relationship between Puerto Rico and the United States has been a strained one. With the exception of two American-controlled territories—Puerto Rico and the U.S. Virgin Islands—Caribbean nations are foreign countries. Puerto Ricans have been citizens of the United States since 1917 and are not considered immigrants of the United States. The piece of paper so many people struggle to obtain, which signifies the American Dream, was eliminated. Puerto Rico has been a U.S. commonwealth since 1952. She has been bound by debt and damned to see the torture of her reflection. Her daughter, Vieques, has been violated by U.S. military exercises for years. Paperless, nonetheless, the significance of the U.S. imposition remains. We have a false belonging, predicated by the absence of "paper." No need to prove you aren't foreign. The U.S. and P.R. are practically family. Master, with slick strips and the sparkle of promising stars, likes to keep her "rich" port open. Puerto Rico and its borderless borders successfully keep us in our place. My parents left the island to go to what some refer to as the mainland, to start a life and get work. My parents' migration and our experiences of that reflect similarities to some immigrant experiences. Both my parents knew almost no English. My siblings and I spoke Spanglish and sort of taught our parents to speak English. My parents spoke to us in Spanish, and we'd reply in English. Speaking Spanish in public, outside of our neighborhood, was often experienced as disrespectful to non–Spanish speakers. I was occasionally bullied—hair pulled, name-called, and forced into fights because I was a "Porta Recan!"

My Blackness is irrefutable when you look at my mother or anyone from her side of the family. Upon first glance, you can guess that I am a person of color. Even as a light-skinned person, I never passed as white. Where were my people from,

What Flows through Me 37

exactly? There are currently over one billion people in Africa. In my irrefutable obscurity, there is land, but one with no exact location. My mama's people were slaves, my dad's side was mostly Spanish, and, on both sides, we have Indios. Spain, Boriñquen a.k.a. Puerto Rico, and somewhere in Africa are where my people traveled from, lived in, and were taken from.

Where do I locate my Blackness or African ancestry, without ever knowing where I am from? Is knowing location necessary to legitimize a claim? Location is almost a false requirement for indigeneity. Whereas one drop is enough to be Black in America, it takes blood-quantum proof to claim indigeneity. One requirement demonstrating a taintedness to Blackness, the other a scarcity, and both rooted in colonialism.

In 2017, after decades of contemplating, I participated in a five-day, four-night ritual to earn my Taíno name and to connect to my *semisaki* (sweet spirit or guardian spirit). Under the guidance of my mentor and Behike (Taíno ceremonial leader), I did one of the most intimidating, scary, and life-changing things. After gathering all the equipment I needed for my quest—tent, water, journal, books, instruments, and myself—I headed to be alone in the woods. Every morning and every night, the Behike would drive to the wooded area I was camping at to lead me in song, ritual, and contemplation. Every day he would leave, and I would have hours in the hot sun, hiking, observing, writing, drumming, dancing, and paying close attention. What felt like weeks later, I walked out of the woods, dehydrated, exhausted, and connected. I felt a re-rooting of sorts. I wasn't in nature, but with her. I introduced myself to myself for the first time. I sat with myself, inside of myself, and listened. I listened deeply

and wrote. Every day, I wrote my feelings and thoughts and captured the visual landscape with letters and childlike drawings. I had waited so long to do this. Denying myself the right because I caved to the "not enough" rhetoric.

My indigeneity is questioned or found lacking, depending on who needs to dissect it. The state doesn't even acknowledge our existence. The original laws that acknowledged federal recognition of Indigenous tribes were established only to apply to Indigenous people living in the forty-nine states of North America. They were never meant to be applied to Indigenous people outside of that. Said to be extinct, we are not counted. Taínos do exist outside of the state. Some have forgotten. It's difficult not to lose your way in the face of such denial. Even today, there is little cohesion when it comes to Native Heritage and Identity in the Caribbean. Many who were born and live on the island have accepted the false claims that our indigeneity is no longer. Others believe that we still exist. Many are a part of the movements to be seen, counted, and acknowledged. The Taíno survival movement, the Taíno revival movement, and Indigenous Caribbean Resurgence are just a few groups working toward un-colonization. During the aftermath of Hurricane Maria, Puerto Rico's struggles were uninterrupted. The growing debt; the debate over statehood, independence, or whether to remain a commonwealth; and the fight for ceremony, ritual, and the preservation of Taíno language continue in the undercurrent.

My people—gender explorers, Puerto Ricans, gender contemplators, Boricuas, Black, Natives, and even gender revolutionaries—continue to consume the food and spirits that once satiated. Were you born in Boriñquen? Which side is Indian? How do you know, blood quantum?

Nowadays, we witness the spewing out of the forcefully manipulated toxins. For some, it is an awakening to the effects of colonialism, and for others, an understanding of their lineage and the loss of not having known. We are unlearning and relearning history, family trees, spiritual practices, song, and dance. The ye olde mold ideology rears its boring shape once again to position a singular Native identity: "You don't look Indigenous." "Did you grow up on a reservation?" I cannot help but smirk at the idea of my legitimacy sandwiched between Native American-tear-shedding-characters in protest of pollution, and depictions of modern-day Africans living in the jungle among lions and giraffes. My Blackness comes into question because it's often conflated with African American. What can I claim—African heritage or Black diaspora, or Afro-descendance? I wasn't born in Puerto Rico, but my parents were. Am I not a part of them? Where do I situate myself? If location, land, and body dictate legitimacy, am I real? Do I even exist? Is my gender legitimate? Am I authentic?

Sixty Percent Water

Where do I locate myself within the constraints of white supremacy and my inherent journey to self-actualization? These attempts at displacement try to strip us of home, language, spirituality, and family. The taking of land, our sexualities, our gender expressions, and reproductive rights seek to displace us in our totality. Actively trying to strip us of our core—how we speak, who we honor, how we love, who we love, our family constructions, and how we express our genders. My struggles with the legitimacy of my gender fluid identity, the invisibility of the Taíno, and my contemplating

Blackness stem from the long-term effects of colonization, regurgitated ideology about binaries, and systematic constructions of racism.

Where do I locate myself? I locate myself among, of, in, and around the man, and self-made cookie-cutter-edges. I go above, beyond, and back again. My identity is not migrating away from something or attempting to colonize another, but it is journeying to me. Within this journey, my struggle teeters. I don't exist inside of myself, only. I take in all that's around me. I absorb it into me—saturating my pores beyond the blood and plasma—it alters me. Much like the belief that human speech or thoughts have extraordinary effects on water and how *it* is altered. Positive words and emotions, soft music and positive prayer focused on the water will formulate beautiful crystals, while negativity and vulgar music produce unsightly ones. Using water as an extension of fluid(ity), I extend my fluidity beyond identity and expression to incorporate the depths of me. I am no mirage. I am no picture of thirst-quenching water in a dusty, sandy hell. There is no illusion because illusions would indicate the absence of something and there is no absence. An illusion would indicate that there was a yearning for something so great—and which could not be attained—that hallucination took over, so as to give hope. A survival mechanism of sorts, but I am no delusion. Armed with the alkaline crystal armor within 60% of my body, I am held. I break down the water in me. Visualizing what cocoons it. Does the conformity of a fearful world seek to spew negativity at me? I choose positivity and vision to seep into 73% of my brain and heart, 83% of my lungs, 64% of my skin, 79% of my muscles and kidneys, and 31% of my bones. I work hard to maintain the beauty of the crystals in me.

In my wildest fantasies, I am real. What is water but life itself, and if I am a part of water, the very essence of existence, therefore I am. Fluidity flows in and around me. The cyclical waves of my heritage, my sexuality, and my gender rise and beautifully collide. It's taken time to appreciate the greatness of their beauty within waves several feet high, able to consume anything in its path to surf-worthy tides, giving the ability to explore. I am fluidity personified. I'm your complication. I alter your perfectly constructed reality with my layers of identity, all of which folds into itself. We are forced to "relocate" our minds and bodies. These mechanisms of forced migration, however challenging, do not displace me at my core—my sense of self. The beautiful crystal formations within me grow stronger with my knowing.

Water connects the continental bodies of my people—the Caribbean Sea and the Atlantic Ocean. In "M Archive: After the End of the World," Alexis Pauline Gumbs, writer, independent scholar, and poet, beautifully depicts, "There may be a causal relationship between the bioluminescence in the ocean and the bones of the millions of transatlantic dead. . . . What the dark scientists are saying is that now that the bones are there, as fine as sand, the marrow like coral to itself, the magnesium and calcium has infiltrated the system of even the lowest filter-fed feeders. . . . So any light that you find in the ocean right now cannot be separated from the stolen light of those we long for every morning."[1] "Who or what am I?" is asked at the backdrop of society's limited comprehension of self in an oppressive world. An understandable question when having to gauge safety. And yet, I was asking the wrong question. I have always known who I was. I've always been there. Colonization helped me forget, but

we are slowly remembering. I am guided by the light of my people—fighters. I am cradled by the *hupias* (ancestors), and I am journeying back to myself.

Note

1. Alexis Pauline Gumbs, *M Archive: After the End of the World* (Durham, NC: Duke University Press, 2018), 11.

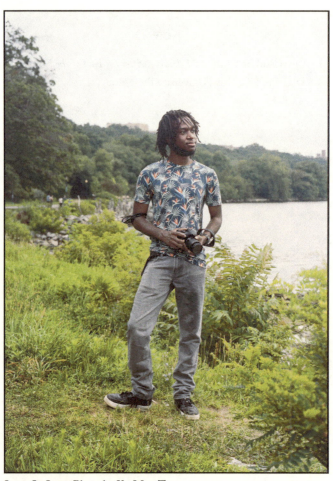
Jonas St. Juste. Photo by Ka-Man Tse.

3
Jonas and the Flowers

JONAS ST. JUSTE

I don't think I'm that interesting
I strive to be a noteworthy photographer
I like to share and know that my pictures made a positive impact
I'm sad and worry about my future
I just want to dedicate my life to art
Live leisurely
Not think about if I'm resting too long
Not worry when I'll get money next
I want to beg the universe for mercy, more than it has already given
It's low light, and has been all day
It's already 5:30
Can I just lay in bed and start again tomorrow
My throat and nose feel weird
Did I catch COVID
Will I pass it to my mom, will my mom die
It's gray. It's been gray all day.
Haven't spoken with my pen pal. Last thing I said to him was I'm sorry for not writing back. I've been so, so sad
I'm a bucket that cannot be filled
And I'm terrified that it could only get worse.
Maybe that magic feeling I get when taking pictures is the feeling of control
I can feel in command over the order of things in frame.

What am I supposed to do, come out as black and
 non-binary
Of Caribbean descent and masculine fluid
Black American and gender fluid
In a nice shade of blue
Blue, black
My color is black, my gender is blue, or blueish gray

I'm not ready for any of this
Why did I live so long
Why was I spared
This place isn't for me
They cut and stab me
They beat me
They throw me away
They try to lynch me and I could breathe for so long until
 their rope withered
Worse, they ignore me

Rage, rage
And I'm dying from the blight

In pure art, I can run away
If I just lose myself enough when I'm on the other side
 maybe I won't get pulled back, I like to think.

And it was like blood in the water rising to the surface
Photo offerings to god
The idea of destroying my best picture of the day
 as a ritual

Visual idea
Hiding in tight spaces

Photo by Jonas St. Juste.

Jonas St. Juste, a practicing photographer and studious student. Born and living in New York City, I picked up a passion for general photography at a time when taking pictures of light eased my sadness. Now, photography has become a relationship filled with subtle communication and psychological engagement, choosing the image I feel has something for me to say to others.

The following is adapted from my dating app description that someone else wrote:

> About me: I'm young, in my twenties. African American, quite lean, possess a defined and sculpted look. Five foot nine, approximately 120 pounds, great smile, sunny

Jonas and the Flowers

Photo by Jonas St. Juste.

disposition and cool natural hair. Endearingly sweet, and cute, majoring in anthropology and sociology, minoring in ethnic studies and critical race theory. A budding photographer with an artistic eye. Athletic, gardens, and nerdy hobbies. Admirably open and uncynical. A light voice with gentle, subtle intonations.

Hi folks, I went on a hike through Riverside Park earlier this week when it started getting foggy. I'd be happy to share the photos I took.

I ended up traversing through trails that went off into obscure areas, which to be honest was arousing, since I am finding a kink for the concept of open air, hidden debauchery.

Get an electric can opener for mom.

I really just want Pax University to just forgive that mistake and let me finish. I'm unemployed, behind on rent, so if I was making 10k, why would I give it to them at this point or ever? That would be enough for me to live off of.

Photo by Jonas St. Juste.

New thought: "I don't owe my abusers anything"

I
Hate
You
So
Much

 Reimagine myself as an alien
 The xenomorph
 The oankali[1]

 Imagining the self as a sci fi character
 Oankali[2]
 Ooloi
 Sensory appendages

 Mutant cyborg story
 A cyborg and xyr technological living-camera companion,
 taking pictures[3]

Jonas and the Flowers 49

It's like an avian creature. It comes and goes[4]
A story about a group of artists
Free to art
Free to be artists—as reparation
The luxury
The luxury of rest
In a world of ones I feel like a zero

Meaning becoming significant to search for and make

Photo by Jonas St. Juste.

Hearing the call of photography

I walk with the existential dread of not mattering
Perpetually marginal

Negligible
BLM seems like a suggestion rather than an inherent way of life
The weight of my existence weighs differently compared to my numerous counterparts
I walk thinking it wouldn't matter if I died
My self doesn't offer the value I need from others
A secret I have is that I believe I'm at my best when I lose hope of self-preservation
I can get more value out of life by putting my own at risk.
Whatever I get is more than I'm worth
High risk, high reward
The best-case scenario, I get something
The worst case, I die. Yet spared from my existence.
Marginal. I'm a marginal error
The one that slips through the cracks
Maybe the cracks were huge anyway
Nothing significant to lose. That's when I'm at my best.
> My existence snuffed out in a mere breeze. No notable resistance.

Is it bad risking a cent to get a dollar?

I am the cent. So, I get to do more because, really, what am I worth?

Do sex work
Post my art without caring if it's good enough (it will never be good enough if it comes from me)
Talk about and explore kinks

Let both lives intersect
Let people know my name
Because if it's anything besides death, it's more than I'm worth.
Pick a gender
Pick a sexuality
Be pan, gay, straight, asexual all at the same time, or none, or rotate
Pick an aesthetic
Dream up anything you want
Who minds what an ant is doing?
Criticize the university and departments, bite the hand that feeds, it doesn't matter. No one is listening, no one will acknowledge. Screaming into the uncaring void. This is it. This is my place. My base, foundation. And it's only luck that I'm not in a worse place.

Extracts from personal correspondence:
I haven't come up with any art projects in particular. Still studying photography online. But currently I have

Photo by Jonas St. Juste.

been focused on learning the Lenape languages and thinking about my relationship with the natural world around me.

Thank you for asking! I've been doing okay. I'm really happy about the birds and squirrels that've been coming to my window since I started feeding them. And I've been enjoying their presence and the routine of preparing food and water. Before, I was considering getting a pet bird or fostering a dog or cat. But developing a connection with local animals has felt like an easier start before committing to having a household animal friend. Other than that, I've been happy with learning and applying Lenape languages, and studying photography. My anxiety about finding work has eased a bit since I applied to a trade-learning program and I'm hoping the end result will have me finding regular work.

Not quite sure.

I try to make expenses less than 20.

I just know I'm not in a good place financially and have been relying on gig work and aid.

Hi. I no longer wish to receive information about events. I haven't been involved with the Office of Multicultural Affairs in years and I'm emotionally exhausted from Pax University, its obstacles, its issues, and false hope to the point where it feels like beating a dead horse. I've publicly written, spoken, and self-published about Pax University's issues with avoiding accountability, racism, sexual assault, exploiting student labor, and much more. I even sublimated my criticisms into forming an autonomous student-led group years ago. From Pax University, I have not received so much as an apology, compensation, or acknowledgment. Pax University, figuratively, spat in my face, and then turned around to readily show their capacity to love and care to others, excluding

me. Everyone has their own agenda, and anything that has to do with radical transformation or escaping from the ongoing dynamics is not part of it. I won't lend my presence or voice any longer.

[laughing tears emoji] tbh i think it's the folks that become Pax tour guides and ambassadors. Because I don't get how Pax can be so horrible through and through, pretend that it is not, and nothing happens. Like where are the major investigations, where are the arrests, where are the shutdowns? How is this still functional? I know I'm spiraling in rants. I get so pessimistic because I think if no one can get Pax to do the minimal compassionate things what hope is there for any institution that is bigger than Pax.

It felt like everything I did she found threatening. Sleeping on a couch, walking through the hallways, sharing my stories. Even when others knew she was wrong, they wouldn't hold it against her, speak up, press her to apologize. She was the boss, and I was marginal. As long as she was nice to people who looked like her things were in order. So, when I heard the news that she passed away, I didn't mind. To everyone else she was their white knight, and I was the terrorizing dragon who needed to be slayed, or the angry black that needed to be institutionally lynched, and whose absence was to be celebrated.

You took my money and gave me hell.

Staring into the light of the moon
Let its light pierce my eye

My race is my gender
I'm black amab
The most direct route, yet uncomfortable, is the relationship
 of masculinity and blackness.

Photo by Jonas St. Juste.

I don't speak with authority
I cannot
How can I say what's real about how people perceive me?
No one has ever told me

Always "Are you a top or a bottom?"
But never CAN you top or CAN you bottom?

> *I was exploring sex with cis men, particularly on Grindr.*
> *I never had sex with anyone through the app and I found I*
> *didn't need to.*

Jonas and the Flowers

> *It was the fantasy of having sex with strangers that **did it** for me.*
> *I resented the question nevertheless. **Why?***
> *It was annoying, asking me to be the first one **vulnerable** while the other guy can be as vague as they **want** about what they **like**.*

I just took my image how I saw it
And believed that the world secretly believed
Sexuality and pornography
Trending and popularity
I didn't know who was watching
But it became safe to assume everyone noticed
Like being put on display
I read it as the world's secret desire
And the algorithm said "Yes, this is how people want to see my body"
A fulfillment of two extreme gender aesthetics meeting together
The hardness to their softness
A sort of heterosexuality, even the sexes are the same.
　　Because the genders aren't.
The aesthetic of primal sexual mythology

> *Oh! You're talking about "BBC"(Big Black Cock).*
> *You can never get over that, **huh?***

Maybe I did internalize it

Primal, physical mechanics of the body, base feelings,
A magical object to introduce the civil world to a more natural one
Their noble savage, magical negro
Their wild man, their classical satyr

We are like a fae kind to them.
Luring them
And awaking some catharsis
Through lust
Magical blackness

Do my peers watch this? I worried
Mel Gibson, "a pack of . . ."
But I only observed at a distance
BBC (Big Black Cock) parties

What does it mean to not be attracted to white men

I didn't want to be a man
Yet I desire the respect given to men

I felt I must betray the archetype
I didn't want anyone to associate me with the sexual fantasy

Because that's what it all was, a fantasy. A momentary escape and pretend.

Reality always present

Re-creating my body
How does the demi-male act
Have sex?

Anatomy
My personal fiction
Alien, intimate sex

Where are you in thought?
Where am I?

Photo by Jonas St. Juste.

> Photography and artistry
> Relationship with ecology
> Relationship with anger
> Learning Lenape
> Trying to be tough

Feeling good enough
Wanting nature to reclaim me

A day in my life
I woke up
Took my medicine and vitamin
Stayed in bed and binge-watched Team Four Star's
 Dragon Ball Z Abridged
I remembered my desire to feed the birds and squirrels
I got out of bed
Made the bed
Refilled the trays with water and food
Mixed with bird seeds, almonds, and leftover blueberries
 from yesterday
When I went into the kitchen two house sparrows flew
 away from the planter in front of the window
I attended the plants in the living room, removing a dying
 piece of Kalanchoe *blossfeldia*
I smelled the herbs we had, basil, thyme, and lavender.
 Touching them and working out their scent
I texted my girlfriend with suggestions about what I
 could eat
I found a couple of these breaded potato foods; I warmed
 and ate them
I saw a blue jay land outside my window. I slowly walked
 to the window to see it. I took off my sandals to be
 silent.
But it moved out of sight by the time I got there
I prepared packaged ramen and mixed in bok choy and soy
 sauce
I saw the blue jay fly off during my preparation. And
 it started making its loud calls. I remembered I
 watched a video on YouTube that said jays were loud

or silent depending on the season. I rewatched the video.
Then went back to *DBZA*
A roommate came and left
Then I finished my ramen and washed my dishes
And went back to bed with my binging
I felt tired and sleepy but didn't put away my phone despite closing my eyes and lowering the volume. I wanted it to keep playing in front of my closed eyes no matter where I turned my head.
My girlfriend came back from work
And I put away the phone. Feeling loose from its embrace
She laid in bed with me and we slept.
She got up to eat and I continued sleeping
It felt like hours had gone by, and it's now the afternoon approaching evening but I just want to keep sleeping

My girlfriend wakes me and helps me stay awake
There are spiders in your head

Your wrongdoing
Your injustice puts a curse on all of us

My blackness having an ascribed masculinity

It's not a gender-neutral body

Though I like the aesthetics of masculinity with a preference over femininity
English-speaking world
Masculinity is blue
Femininity is pink

Masculinity is pants
Femininity is skirt

I'm more masculinity than a white male body of the same
 body size by default
Blackness associated with raw strength, athleticism
More tolerant of pain than others

A body for hetero-contrastic-sexualism

To be sexy is appealing to it

I trace the faint lines of my abdominal muscles while
 looking in the mirror, seeing myself shirtless. The
 subtlety of physical masculinity

Maybe because I like the sexual attention but I don't want
 to carry the whole thing, the manliness
I can grow my hair long in this body

Concerned about what I am
My shape
Sexual presentation
How do I have sex?

Big question for me. Like how do you have sex with an alien? Sex is to engage sexually. But how? By doing it sexually? But do what sexually? Engaging. How do you know when you're . . . ? Sexing? You know when you're sexing when you engage sexually. No, I mean what about genitals? They can be engaged sexually. But you're saying they don't have to be? I like to curl my form about a partner and dream.

Notes

1. An alien species, along with the ooloi, from Octavia Butler's novel trilogy *Lilith's Brood*.
2. The oankali, again. They made a real impact on you. Why are you afraid to say more? Because I don't trust myself to say the right things. Why? Because I'm human, and I don't trust people anymore. I would trust the oankali, though. And the mutated cyborg character I've fantasized about.
3. And speaking of the mutated cyborgs, a cyborg taking pictures? Yeah, a cyborg taking pictures in an apocalyptic (or maybe postapocalyptic) world. I remember what inspired this idea, this fantasy. It was that manga, and the corresponding anime.
4. I've been feeding the local birds and squirrels in Bushwick. House sparrows are my favorite if I still have favorites. They're small, brown, with beautiful voices. Very cute. I've also gotten to know the mourning doves, cardinals, and blue jays. I even learned each of their names in Lenape.

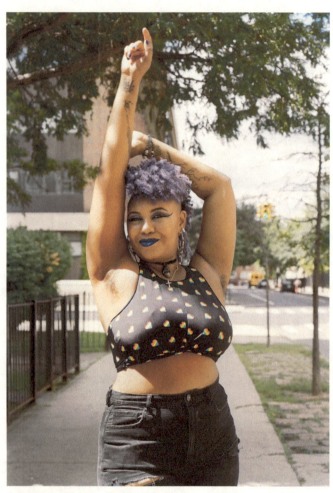

S. L. Clark. Photo by Ka-Man Tse.

4

What Is a Pussy Anyway?

S. L. CLARK

Every time I go to the doctor I'm faced with the same type of anxiety. The same concern that the doctor, the nurses, the front desk staff, and the other patients will wonder why I'm there. Why I'm at this particular clinic and not one of the other hundreds around the city. Today is no different.

I get up, take my meds, brush my teeth, co-wash my hair, and shower. I make instant Café Bustello—no sugar, dairy-free caramel creamer. I sign into Zoom to teach my first writing class for the day.

Eleven A.M. Class is over. "See you next week!" I call out to my student. I close my laptop. I have to summon an Uber in a half hour to make it to my appointment on time. I go to my room to change . . . and stop. I don't know what to wear to this appointment. I shuffle through jeans, t-shirts, and flannel. It's just a doctor's appointment and I'm supposed to be getting a Pap smear today. I settle on black joggers, a black cut-off muscle T, and my black Docs with the pride flag stitched into the side. I adjust and readjust and adjust and readjust my sports bra. I can't afford a binder that will hold

in a chest this large, and the sports bra keeps giving me uniboob.

I look in the mirror, uncertain about what to do with my hair. Leave my fro'hawk down? Put it in a bun? I don't have time for French braids. Pompadour the front and pin it in the back? "It's just a doctor's appointment," I tell myself. I opt to leave it down. It's still damp and could use the drying time. "Eyeliner?" I ask myself. I reach for my makeup bag and pause. Is that too much? Should I avoid the makeup? "Anyone can wear eyeliner!" I know that, but not everyone is aware that anyone can wear eyeliner. I put the liquid liner down. No dramatic cat eye today, even though it makes me feel safe.

I look at the clock. Eleven thirty-five A.M. I summon the Uber and select a mask. *Royal purple with big, silver letters on the side that say "They/Them."* I smile at the mask that a friend custom-made for me and wrap the loops around my ears. I put on my battle jacket and run out the door, promising my cat I'll be back.

I'm twenty minutes late for my noon appointment. I'll be late to my own funeral. I dash through the doors of the trans health clinic and am stopped short. There's a line for temperature checks and someone at the front is being an ass. I get my temperature checked and am asked the standard list of questions regarding COVID exposure. I'm allowed in.

My anxiety starts again. I get to the front desk and am informed I am late. I'm aware. I'm checked in anyway and take a seat in the waiting room. Chairs have been removed since the last time I was here, and the remaining ones are the standard six feet apart with dividing panels. Aside from myself, there is one other person here. They sit on the opposite side of the room, facing me. Shoulder-length, basic brown hair with a hint of a wave to it and a fresh undercut

on their left side. Plain, white cotton mask. Loose-fitting, multicolor Hawaiian shirt tucked into black, distressed jean shorts. The first three buttons of the shirt are undone. Brown boots with the socks puffed just above the top. Teal nail polish can be seen whenever they lift their phone up. Thin, with an unassuming chest and white. A gold-star queer.

I should look like them.

A weird dipping sensation happens in my gut. I fold my arms across my uniboob and slouch down in my chair. I narrow my eyes at a spot on the floor and stay that way until my name is butchered by the triage nurse.

"Sania?" Her cheeks rise above her mask, "Did I get that right?"

"Sa-nee-na." I pronounce for her.

"Sorry about that. This way."

There are only two Saninas whom I know personally in the whole world. My aunt and me. When asked by other queer people, especially other trans people, why I still go by my birth name, I tell them, "Because that's my name." We, as humans, are the names we identify as, and our identities shift throughout our lives, sometimes a little at a time, sometimes greatly. When my grandmother played a game of anagrams with "Nina" and landed on "Sanina," she knew that would be my aunt's middle name. When my mom was pregnant and unfortunately serious about naming me "Reminisce the Essence" (the nineties were fucking weird) and my grandma talked her off the ledge, my aunt proposed naming me after her instead. "If it's a girl, will you name her after me?"

Names are important in my family in that they are homage to those we love and, sometimes, have lost. My great-aunt is named after my great-grandfather. My mother and great-aunt share the same middle name. My aunt is

named after my grandmother. One of my brothers is nicknamed after an uncle who died long before we were thought of. If I ever decide to have children, the first one assigned female at birth will be named Mahniya, my little sister's middle name.

When the midwife announced that the head full of hair my mother had just birthed was a "girl," everyone in the room knew that I was Sanina. I am lucky in the fact that my family got my name right on the first try. Maybe not my gender, but certainly my name. Because at no point in time have I ever heard my name and felt dissociated from it. I have never looked at my reflection and thought that my name was truly something else. No matter the ways in which other aspects of my identity shifted or revealed themselves, my name has always been Sanina. I was blessed with the honor of being named such and so I will remain.

"Sa-nee-na." I pronounce for her.

"Sorry about that. This way."

I follow the triage nurse down the hall and around the corner to an examination room. She takes my vitals and asks me the standard list of annoying questions about my mental health that I don't want to answer because they're always so fucking vague.

After assuring her that I'm in twice-weekly therapy, medicated, and won't off myself the moment I step out the building, she pokes her head out the examination room to summon the doctor.

"She's ready!"

She . . .

My stomach takes flight the way it does during the first drop of a roller coaster. Everything around me goes silent except for the loud "she" that keeps echoing in my head. I

don't correct her. I shouldn't have to. My pronouns are on my mask. They should also be on my chart, which she was just looking at. I'm too confused to say or do anything, so I just wait until the doctor cheerfully saunters in.

She's new. My other doctor left for another clinic right at the beginning of quarantine. I've only met this new doctor via tele-appointment. Despite her having access to all my health records, I still have to give her a quick rundown of everything and remind her why I'm there.

"I'm due for a Pap smear," I finish.

She goes on to ask me a bunch of questions about previous exams and uterine health and is shocked to find out I neither have a regular gynecologist nor have ever had an actual Pap.

"Last time I had any kind of examination outside of ultrasounds was when I first had my IUD installed."

"Oh! That's no good! That's all the more reason for you to have a regular gyno. As a woman it's necessary!"

There's a glitch in the matrix as "woman" replays over and over again. She. Her. Girl. Woman. Ma'am. Miss. Etc. These words always seem louder than the rest of people's sentences. These words immediately force me to recall other instances of being grossly misgendered. The use of "woman" and the discussion of my uterus ushers one specific memory to mind.

I had just finished cohosting a show with another drag performer. We'd done numbers back-to-back for an hour as the opening to a burlesque show, which was followed by karaoke. I, now out of drag and back in goblin mode, had just sung a P!nk song and was riding a wave of exhilaration from spending a night doing what I love, surrounded by other queers.

I was chatting with the bar owner while he was overpouring my next drink when he mentions my song choice and vocal range. The drag queen hosting karaoke interrupts to say, "Oh it's okay. She's a girl."

Confused by what that had to do with the song but having a rare moment of confidence, I corrected her. "Actually, I'm nonbinary and my pronouns are 'they/them.'"

She whirled on me and loudly exclaimed, "Yeah, well you have a pussy, don't you?"

I froze. One, because I could not believe that this was happening in a queer space. Two, because I didn't know the answer to her disgusting question.

Do I have a pussy?

I thought about that scene in *Lady and the Tramp*, when Lady discovers her owners have had a baby, but she doesn't know what it is. As she paws her way up the stairs, she sings, "What is a baby anyway? Oh, what is a baby? I must find out today what makes Jim Dear and Darling act this way."

She kept glaring at me, waiting for me to respond, but all I could think was, what is a pussy anyway?

She eventually walked away and left me there, staring into my whiskey and Coke, trying to figure out what the fuck had just happened.

What is a pussy?
Do I have one?
Why does it matter?

As I downed my drink and immediately asked for another, I realized that I truly did not know because I don't sit around and think about my genitals in regard to my gender. I don't think of my vagina as a woman's vagina. I know it as part of my body. And since I am not a woman, there are no parts of my body that are "women's" parts. However, this drag

queen, in asking about my genitals, was asking if I was a woman, despite me explicitly saying I am not.

It doesn't matter how I identify. It doesn't matter how I want to be perceived. Clearly, the only thing that matters is pussy. And since I'm not a Barbie or Ken doll, since I don't have a penis, I guess I have a pussy.

But it's a nonbinary pussy.

These are nonbinary breasts.

These are nonbinary curves.

This is a nonbinary ass.

I am nonbinary. Therefore, this is a nonbinary body. Not a female body.

That bitch can go fuck herself.

I cannot tell my new doctor to go fuck herself. Trying to give her the benefit of the doubt, I turn my face while speaking so that "THEY/THEM" on my mask is directly facing her. She responds, looking at my masked face, and refers to me as a woman again.

I'm going to fucking scream.

The whole point of me joining this clinic two years prior was because I was exhausted from all the horrifying experiences I'd had at other hospitals and clinics. Even if my doctors weren't homophobic, they were transphobic, or they wouldn't take my chronic pain or other ailments seriously, or they kept trying to lock me up in the psych ward. I came to this clinic because other trans friends loved their experience there and recommended it to me.

These friends were thin and white.

Now, this is not to say the experience I was currently having was the fault of my friends. It wasn't. But I can guarantee that the anxiety I'd been having walking through the doors for the last two years, feeling as if I did not belong in

that space, was never felt by my thin, white trans friends. It may have taken two years for this experience to happen, but for the entire two years, I anticipated it. I did not trust the safety the space offered because I have never been able to trust the safety queer spaces claim to offer because that safety often only applies to white queers. Whiteness has dominated the queer and trans narratives despite Black trans women leading the movement. This white-centered presentation is what aided in, what I consider, my delay in realizing I was not cis.

I went to a very, very incredibly gay school. The running joke was that if you weren't already queer when you got there, you would be by the time you graduated. Looking at my friend-group from that school . . . yeah.

Funny enough, I arrived as a freshman already identifying as bisexual. I'd found the word when I was fourteen years old and immediately knew that everything I'd been feeling could be described by that word. By the time I got to college, I was the bisexual spokesperson. I found every opportunity to bring it up and encouraged all my friends to explore their bisexuality! Everything I wore (that wasn't black) was pink, purple, or blue. My hair, my sneakers, my bedspread was like the bisexual flag.

Obviously, at that time, I encountered a lot of biphobia from straight and queer people. It didn't deter me, though. In fact, it made me aggressively bisexual. A bisexual overlord. Bifurious.

While campus queer politics failed to shut down my bisexuality, it excelled in shutting me out of the conversation surrounding gender. It took me until sophomore year to accept that I was a feminist, and even then, I wouldn't say it aloud. It took that long because the campus feminists

were not saying much that resonated with me. It took a conversation with my suitemate, another QPOC or queer person of color, to realize that the reason we were both put off by feminism at the time was not because we didn't believe in the message, but because the discourse was predominantly controlled by white women and we couldn't connect with their experiences and desires. We were and are feminists! But our feminism comes from Black and Latinx history and experiences. Our needs cannot be met by white feminism.

As a by-product of being pushed out of the feminist discussion about gender, I was also pushed out of the queer discussion about gender identity. How? Because the same people were running the conversations. The same people were running and attending the events. And those people all. Looked. The. Same. Petite, androgynous white queers with similar haircuts, wearing similar outfits.

My tall, wide, Black ass with ass-length braids did not belong, and there were few, if any, people around to convince me those were spaces for me. I didn't even try because I'd been in that predicament before. With Goth groups. With anime groups. With theater groups. With technical dance groups. I would eventually find communities of Black people like me, but only after graduation.

Finding one such community is how I got smacked with the "You ain't cis, sis" brick. Seeing various other nonbinary BIPOC (Black, Indigenous, and people of color) living their best lives and feeling their best selves opened my eyes to the realization that the white queer and trans narratives were not all there was. That, like me, other Black and Brown trans people felt ostracized from the main conversation and, like me, found their way into queer communities that actually loved and accepted their transness in all its multitudes. That

if there was no wrong way for white people to be queer, how could there be a wrong way for Black people?

Who is anyone to tell me that my queerness and transness are wrong?

I was twenty-two when I started questioning my gender and going by she/they pronouns. It was another year before I dropped the "she" altogether. I realized that if I gave people the option to use either, most of the time they used "she." However, with other people who went by more than one pronoun, they chose the gender-neutral form. It became clear to me that they chose the pronouns based on how they perceived me, and no one seemed to perceive me as "they." I dropped "she" to force people to acknowledge me as a gender fluid person whether they felt inclined to or not (at the time of this publication, my pronouns are they/he). I was no longer going to allow people to dismiss my transness simply because I didn't fit the aesthetic or narrative they felt I should.

But dropping the "she" didn't matter. My transness continues to be dismissed.

The doctor never corrected herself or apologized. She never even tried. In a clinic dedicated to trans health, with a big sign about pronouns in the lobby and pronoun stickers at the front desk, she had never even bothered to ask me what my pronouns were. She made an assumption the moment she looked at me that I was cis. She took in my voice, my body shape, and likely my skin and assumed my gender, despite working in a place in which people are supposed to be trained not to do so.

She ignored my obvious discomfort and all my attempts at subtle hints. She ignored the pronouns that were right there on my face. Not only did she make assumptions and no attempts to correct herself, but she drove in, with every

sentence, the fact that she did not view me as a trans person, binary or not. She did not even care enough to ask.

I am conscious of the fact that some part of that interaction would have been different had I been white. That a lot would have been different had I appeared more masculine. That my Blackness paired with my assumed femininity allowed her to feel valid in her disrespect, just as it often has made people confident in disrespecting me my whole life.

As a Black person who was assigned female at birth, raised and socialized as a woman, and who continues to be perceived as a woman for a number of reasons, it is incredibly difficult for me to completely dissociate myself from womanhood, specifically Black womanhood. From the moment I was born, I was susceptible to misogynoir, misogyny specific to Black women, as Moya Bailey terms it. How am I supposed to separate myself from the thing that drives everyone's reactions with me, whether they're conscious of it or not?

Black women have been in the vanguards of many human rights movements, and yet their contributions continue to be erased. From politics to pop culture, to art, or to sports, Black women are constantly overlooked or stolen from. Malcolm X said, "The most disrespected person in America is the Black woman. The most unprotected person in America is the Black woman. The most neglected person in America is the Black woman." And that goes for anyone who has lived or been socialized as a Black woman.

Many of my most traumatic experiences happened to me because I was a Black woman. There was a point when those experiences shattered me, and I didn't ever think I would get back up again. I had to learn to love myself as a Black woman, and I have no intention of unlearning that.

Black women raised me. Black women helped me get up when I fell. Black women showed me love and compassion. Black women let me know it was all right for me to be angry about the things that happened to me and taught me how to use that anger as fuel to get me to the next day. Black women first taught me how to live out of spite and then how to live for myself. Black women have protected me when no one else would.

Even though I am nonbinary, I was born and bred of Black womanhood.

And I love that. I love being Black.

But the world does not love my Blackness. Including the queer world.

Aside from being an editor, an educator, and a writer, I am also a model, a cosplayer, and a drag and burlesque performer. I wear a lot of hats and I wear them well. While I have experienced misogynoir in all those environments and communities, the misogynoir of the queer community is especially audacious.

I have said before and I will continue to say that the queer community, particularly that of the drag and performance community, rides on the shoulders of Black femininity. From mannerisms and speech patterns, to drag and ballroom, to fashion and the confidence to *be*, Black femininity created queer culture as we know it. Yet, Black women and AFAB people are constantly erased from the culture, as we have been erased from everything else. And that is because white people are comfortable with and feel entitled to performing and commodifying Blackness, despite not wanting Black people to exist. The queer community has not escaped this.

I, as well as many of my fellow Black queer performers, have had to work three times as hard in the drag and burlesque scenes to get half as much recognition as our white counterparts (who sometimes aren't even that good. Yes, I said it!) get. There are only ever one or two of us in a show at any given time unless it's specifically an all-Black show. And often, when we are recognized, it's because we have finally presented ourselves in whatever stereotypical way producers and audiences think we should be representing.

I cannot count the number of times a producer has booked me, watched me perform an alternative number, and then exclaimed, "I wasn't expecting that from you!" The silent "because you're Black" never misses my ears. I've been hearing variations of that sentence my whole life. Teachers couldn't believe how eloquent or smart I was. Men don't believe I play video games, watch anime, or love sci-fi. Employers don't believe I have emotions and are constantly telling me that I have an abrasive personality that "brings office morale down." White women don't believe I'm an empath but do act like I've just killed them when I tell them not to touch my hair. Do not touch my fucking hair! The alt community believes that Black people ruin the aesthetic ... I guess the queer community believes the same.

It's funny how Black people are expected to "act Black" at the same time that our Blackness gets stolen from us and rebranded as something else. It's funny how people can be both alarmed at my Blackness and baffled at everything else about me. The first time I was ever in a space where no one questioned any of my identities was at the AfroPunk arts festival. I walked into the lot and knew I was home. I knew I was safe. It felt so freeing to be around other Black people like me and Black people who love Black people like me.

There wasn't an ounce of hate around. Just pure, beautiful, joyful, quirky Blackness. The only other times I come close to that are at all or mostly Black shows, and even then, depending on the producer or audience, there can still be transphobia.

As a queer, trans-nonbinary, alternative Black performer of size, I am hyperaware of the praise my peers get compared with what I get. And it really fucks with my imposter syndrome. For so long I believed I wasn't as good as others because of differences in pay, and recognition, and goddamn follower counts and post views. And then one day I looked at the people I was comparing myself with and realized that it had nothing to do with how good I was, because I am fucking phenomenal at everything I do. I simply don't meet people's expectations of who and what THEY THINK I should be. And I have no intention of doing so. Why should I?

Why should I have to water myself down so that people aren't "intimidated" by me?

Why should I have to hold back on my personal creative expression?

Why should I have to perform someone else's brand of queerness or gender?

Why should I have to be confined to one neat box when white queers don't?

Why should I have to be told to shave by white women who also don't shave?

Why should I be anyone other than who I know I am?

Why?

There is only one person I owe the world, and that's myself. The only person I have to make happy is myself. I am happy and in love with all of my identities. I couldn't always say that. I remember a time when I couldn't name a singular thing I liked about myself. And while that version

of Sanina still likes to whisper in my ear sometimes, I'm a lot more conscious of turning to them and saying, "One day you will be me and there won't be a thing you don't love about you."

I love my queerness.

I love my transness.

I love my Blackness.

I love my Black womanhood.

I love my body and every scar, stretch mark, bruise, fold, and jiggle.

I love my hair. On my head, on my body, and even those faint whiskers around my mouth.

I love my smile and how it exposes all of my perfectly crooked teeth.

I love how fucking intelligent I am and how easy it is for me to talk someone's ear off about anything.

I love my laughs. All twenty-seven of them. Including the one that sounds like a wheezing horse. But especially the one that sounds like an anime villain.

I love being a queer, anarchist, Catholic witch. I know Jesus loves it too.

I love that I have no equilibrium walking, but so much grace while dancing.

I love that my eyeliner extends into my hairline and is sharp enough to puncture a racist's jugular.

I love how funny I am. I'm literally the funniest person I know. I'm a fucking riot.

I love that sometimes I'm mad and sometimes I'm not . . . AS mad.

I love my ability to capture a crowd, to light up a room, to make someone feel safe.

I love being able to admit I'm wrong when I make mistakes. I couldn't always do that.

I love my higher self. Everything I've done has been for them.

I love past me, present me, and future me.

I love me.

And I will never let anyone take that love away.

5
Outside In

Scattered at the Edge, Part Two

ARI SOLOMON

My first error upon returning home from my time away was not answering the phone because I was listening to music on a radio I received as a gift during my NYC trip. Expecting the worst, I lied to protect what was important to me, listening to music on my own terms. My love of music had always been strong, but the selection was always curated by someone else. Of course, in a narcissistic household, secrets of any kind were impossible to hold. Once my lie had been seen through, all the personal items purchased for me by family members in New York were placed in the trash. My heart broke as I saw the physical embodiment of my freedom being thrown away before my very eyes. I was reminded once again that I did not own my body and that my freedom was in the hands of my abuser. When I was ordered to assist in throwing out my belongings, I walked outside carrying my recently formed personhood in a black trash bag. Once everything had been placed in the trash, I was told to get in

the trash and throw myself out. I opened the trash can and looked inside at the putrid buildup surrounding my enclosed treasures as the belief in the words of my commanding adoptive parent began to take hold. I did not deserve to exist when it was apparent that I caused grief to those around me.

The words "I am trash" reverberated through my mind as I wondered how I should begin to fit myself in this trash can. I laugh now at the fact that I really did try to fit myself in that trash can, while my heart stings at the deeply planted belief that I was worthless and solely an inconvenience. My emotions were raw and so turbulent that I decided it would be better if I wholly disappeared. This would not be the first or last time I had been told that I was not wanted by this household. I think back to the times I was told to sleep on the front steps of the house or was driven to the police precinct and left there by my adoptive parent's husband. It is no surprise to me that I decided to improve everyone's situation by running away, believing that I could solve my problems and the problems that others had with me by disappearing. I left with nothing on my person so as to not alarm anyone about my absence. Under the guise of having complied with inserting myself into the trash can, I exited the can and hopped over the brick wall to cautiously cross through backyards to get as far away as possible. I hid among garbage and outdoor equipment, daring to cross backyards only once I had carefully assessed my surroundings. Unfortunately for me, I could not run fast or far enough, and I was caught by my adopted parent and driven back home to receive punishment for the "embarrassing stunt" I had pulled. The months of back-breaking, skin-ripping, and self-esteem-dissolving labor went on for months and months. Even her friends and the teachers at the school where she worked ignored her abuse.

Without a grounded sense of self derived from the typical experiences one would expect an eleven- or twelve-year-old child to have already developed, I was clay in the hands of those who owned me. My sense of time was based on the recurrence of exaggerated punishments consisting of cleaning, maintaining, and running the house, running for miles, thousands of push-ups, choosing my belt for a beating, and sleep deprivation. That freedom I had experienced in New York City seemed more and more like a dream until one day I made the mistake of helping a fellow classmate in our accelerated eighth grade algebra course. I believed that I had learned how to balance the expectations of my teachers while escaping the heavy hand of my adoptive parent. These were some of the lies I told myself in order to be prepared and hopeful for the next day. However, my act of talking out of turn during class to assist a fellow classmate was relayed to my adoptive parent by email so that by the time I got home, the energy in the house warned me that something wicked was coming my way. That evening continued as any other, but the tension in the air made it obvious that this was only the calm before the storm. I woke the next morning with a false sense of security. On the way to being dropped off at school, I was questioned on the incident. Knowing that the truth would not be enough to save me, I hoped that my lie of forgetting a textbook would be enough to absolve me. How wrong I was. Within hours, I watched as the rest of my belongings were thrown out including my well-hidden treasures. In red gym shorts and gray short-sleeved shirt, I was driven to the airport by my adoptive parent's husband, who repeatedly reminded me that I was entirely at fault for my circumstances.

During the whole plane ride back to New York, I stared straight ahead because I had been threatened that if I watched

anything or engaged in conversation with anyone, they would know. Being brainwashed with fear by their household for so many years, I believed them. Even the flight attendant, sensing something was wrong and possibly worried I was being trafficked, tried to get me to open up by asking questions about where I was going and who had placed me on the plane. For the first time in my life, someone who had no connection to T or her sexually abusive husband was truly concerned for me. Overwhelmed with emotions, I lost the battle against the brainwashing and re-wiring, leaving the flight attendant awkwardly attempting to quell my tears by giving me extra snacks and tissues. I could not open up fully to this person because I had spent most of my life with people assisting me for their personal gains without a care for my next moment once the rewards had been reaped. Unable to discern if this person was being truly kind to me or fishing for information to pass along, I continued to stare ahead for the remainder of the five-hour flight. During a short layover in Washington, D.C., I was met by my grandmother, with whom I had limited contact while living in California and who had adopted my brother at my desperate request. Using the story of my childhood combined with the power of a white woman's tears, my grandmother was able to rationalize her request to bypass the post-9/11 TSA without a boarding pass. Thanks to her tactful use of white privilege, I was able to meet with someone who knew me during this tumultuous time. Lying to save myself the time and tears, I told her I was fine and relayed the concern of the flight attendant. In my explanation, she learned of the restrictions that had been placed on me during the flight and immediately told me that I was safe and free. *They did not have the power to hurt me anymore.* As difficult as

it was to believe her words, I boarded the second plane with less fear than I had the first.

Arriving in New York was terrifying, as I had not been back for several years to the fastest-changing city in the United States. I needed to reassess my white great-grandmother's allegiance to her grand-daughter, my adoptive parent. In small steps, I began to trust her, with the first big step for me being her not allowing my adoptive parent to speak to me. Great-Grandma Rosemary prioritized protecting my space to grow and process the trauma by delaying my reentry to school and recultivating my ability to choose for myself. I could even choose what I wanted to eat that first day with her! She handed me several menus and said, "Order anything and everything you like; just don't be wasteful." After several months of city tours, doctor visits, and therapy, I began to attend school again. My great-grandmother and my grandma were aware of what they could give me and what they could not. They prioritized sending me to a school similarly structured to the Catholic school in California but with more diversity. With trepidation shadowed by excitement, I visited the school to see what the next few months would bring me ahead of my eighth-grade graduation. The students were quick to relay that I had failed their expectations of me. They had expected a confident, busty, thin, blond, white girl to show up that day, and I showed up instead with my short brown curly hair, brown eyes and skin, and obvious sense of discomfort with the new curves of my body. Pushed by my great-grandma, I made acquaintances with my classmates by standing by as a generally silent observer, interjecting with a comment, question, or story only when I had assessed that it was the right moment. Powered by traumatic experiences and withdrawal

from medications, I was worried that the idea that I was inherently undeserving of inclusion and equal treatment would follow me from California to New York.

When the summer hit, I was sent to stay with my Grandma Eileen, who had met me during my traumatic layover in Washington, D.C., and who was also the legal mother of my biological brother. Before his adoption, my brother's name was Rashawn, which I loved. When I heard his name, I heard all that we had been through together, so when his name was later changed to Sean, I felt as though our bond was in danger. The brother I knew was being rewritten by the white woman who adopted him. Though I love this white woman, my grandma, for taking him out of that group home and bringing both of us into this family, I grew fearful that the imposed edits enforced on us to varying degrees would erase the identities we worked so hard to build and protect. Confident that my grandma noticed my willingness to appease her, the summers were a protected place in time for my brother and me to bond. We quickly fell into the typical cycle of sibling highs and lows, from fighting over the smell of his shoes in the car during a long drive to headbanging to Korn or Slipknot before collapsing into a fit of giggles. Other times, we shared our deepest secrets and dreams with each other. So when my brother requested one day for me to paint his nails and do his makeup, nothing seemed abnormal to me because we accepted each other as we were. With each other we were able to be our unedited selves, and nothing felt as free as rebuilding our relationship without being under the eye of T. Our bond was unlike any friendship I had ever had, until my brother increasingly began to struggle with diagnosed bipolar disorder. I saw my brother go through a familiar and fearful cycle of medication trials and hospitalizations. As the stays grew longer

and the institutions farther away, I felt our recently reinvigorated bond become brittle and unsustainable. I told myself that if I held onto the memories we had shared and placed no effort into remaining connected, I could protect what we had until he got better. With a hopeful eye, I watched my brother improve but just as quickly revert to a stranger with whom communication was impossible.

Back in New York, with my brother at the forefront of my mind, I was hyperaware that I needed to start making relationships, and quickly at that. The high school that I was due to attend was a Catholic all-girls school. My grandmas hoped that placing me in an all-girls school with a non-white majority would protect me from woes that typically follow adolescent girls who attend co-ed schools, as well as from the isolation that came from attending a white-majority school. I was grateful to be at a school where I felt as though I couldn't be picked out in a crowd. I was able to experience the collective for the first time in my life. We were one class within one grade within one school within one archdiocese. Thinking as a collective was new to me, but I looked at it as a primer to understand how to think as an individual. For most of my life, I was told how and what to think by the authority figures in my life: social workers, officers, foster parents, therapists, teachers, classmates, doctors, and T. Existing with autonomy within a collective allowed me to ask myself, "What do I want? What do I like? Who am I? Who do I want to be?" One of the ways that I refused to conform was to constantly question the information fed to me by the school. I believed that it was through questioning what we were taught to learn that I could assess the authenticity of the subject. My goal was to develop a heightened awareness of authenticity in order to fully embody my authentic self. Through my readings as a child and the trauma I had

endured, I learned that it was possible to completely twist reality to work in one's favor, usually at the expense of others. The Catholic Church has had a long history of perfecting this ability, from the racist Crusades to the missionaries set out on inherently racist missions to colonize and erase entire nations under the guise of saving souls for the Church. Whenever these historical events were discussed in our history and religion classes, I felt the eyes of the other students boring into the back of my head as I challenged the narrative being taught. For example, think about the Black people abducted from their homes and brought to the various ports around the world, and a common consistency in each case is the use of religion by those who operated in and with the slave trade. I questioned and still question how Western religion is taught as the key to a civilized society when the abducted Black men, women, children, and other enslaved people had civilized societies of their own. Stolen from what they knew and beaten to accept a Western name and binary gender role and forced to labor under the cruelest of conditions, how, in the grace of God, was the use of Black bodies for free labor acceptable when one of the most quoted lines from the Bible is "Treat others how you wish to be treated"? When the responses from my teachers came across as weak and unsure, I knew that I was asking the right questions. So I kept on asking even as the circle of isolation grew around me.

As I consumed as much knowledge as possible, I realized that the exclusionary ways of the Church were not limited to demonizing entire races of people but extended to those who sought love in relationships declared forbidden by the Church. When I was taught by my high school that LGBT people who engaged in their sexuality were not welcome in the church and could not be saved, I once again felt myself

being pushed out of the circle and declared not welcome. I had not realized that questioning this declaration of the Church in class would place a target on my back for additional bullying and harassment. I could not wrap my head around this exclusionary love taught by the Church. So I brought home my questions to someone whose gay brother had died of AIDS, my great-grandma Rosemary, sibling of the late Damien Martin. She explained, while sipping a Diet Coke and intermittently clearing her throat, that she had left the Church a long time ago and decided she would converse with her God on her own terms. When she said this, it was as if a spell had been lifted. I then understood that if the Church had no hold over her, then it certainly did not have one on me. I realized that I could take what I saw was important and leave behind what I saw as performative and hypocritical.

With my ties to the religious aspect of my high school behind me, I felt a new level of freedom. The things that I was told were bad or catalysts of doom were now an option into which I dove headfirst. Literature was everything to me during this time, and I consumed an equal amount of anime as well. Literature was my guidebook on courting, and anime educated me on genderbending, which I found extremely attractive. Using these as reference points for what girls liked, I tried to establish connections to other people, with romantic intentions. Sometimes, I would act as that ear or shoulder for folks going through emotional ups and downs. Other times, I asked around to learn more about my potential interest. I remember one certain person for whom I had donned rose-tinted shades. Appearing by her locker with a blue rose, the symbol of impossibility and unrequited love, I would offer the token and enjoy the short conversation that we squeezed in before the first bell. Every

day for more than a week, I tried to move our interactions past my daily appearances to no avail. It wasn't until I was invited to an outing with this person and several mutual friends, only to be left there and purposefully forgotten, that I began to understand. When I brought up the occurrence to a friend, I was told that the whole school knew there was no requited affection from my romantic interest. I felt so alone in that moment, but I also became hyperaware of the barriers and hurdles built and supported by the institutional Catholic Church and school. The whole collective had watched me, whispering and joking behind my back at the futility of my attempts, but said nothing to my face. After a few more attempts here and there with different folks at school, I began to give up on the idea of forming a connection with someone in person and spent more time on the internet with the hope that I could find out what I was doing wrong.

Entering college, I had no clue how the next four years would change me, but I was more than ready to enter a space that celebrated folks who questioned how things were. When I was first applying, I was unsure if I would be accepted by a good college, and my adoptive parent's words echoed with many others that I would never get into school and would be homeless and pregnant by seventeen. If not for a chance meeting with the actor Margo Martindale, I would not have even applied to the college I ended up graduating from. She listened to me while browsing at a shoe store and urged me to follow my ambition for a well-rounded education centered on the performing arts. I'd never had a random encounter like that and took it as my push to apply early. With a notebook listing my questions and dressed to the nines, I attended the college tour hoping that I would find exactly what had been advertised on their website.

Unfortunately, when I arrived, I noticed that the school had more white students than I was used to. I found myself searching for Black and POC (people of color) students, teachers, staff—anyone! They were there, though, and it wasn't until I saw the Higher Education Opportunity Program office that I felt as though I could see myself on campus. Most of the students entering and exiting looked like me or folks I had grown up with. With fears of isolation behind me, I auditioned for the theater program, got the news that I was accepted, and eagerly looked forward to my first day.

Moving into the dorm was exciting to me, as I had not lived with other people as equals in my entire life; I had either a parental figure, abusive or otherwise, or siblings who received special treatment. So much excitement had built up for me that I was not ready for the disappointment that would follow. I was aware of my roommates' backgrounds, but I was unaware of their whiteness. Traditions, habits, and expectations of mine seemed to bother them to no end. For example, when I was growing up, tuning in to the nightly airings of the miniseries *Roots* during Black History Month was started by my adoptive parent and difficult to leave behind me. With my roommates discussing race and inclusion, I wanted to contribute by bringing something that was part of my own experience. My original plan was to reserve a room and play the miniseries on the television, but time was against me, as the month was also popular for football viewing. My next option was to simply watch it on my laptop in the kitchen so that anyone coming and going from the bathroom, kitchen, or front door could join in the viewing. I watched the whole thing alone. Initially surprising to me, my roommates had never seen *Roots* and only knew it as "that Black movie about slavery." First of all, it is not a movie, it is

a series, and their limited understanding of the Black experience and refusal to increase that knowledge was disturbing to me. They said all the right things, but when it came to growth, engagement, and action, I saw nothing. So, I set that on my back burner to simmer, since I still had to live with them for a few more months.

Back in high school, I was part of many school clubs, mostly because of the free food but also to have something extra to do after school. From the French Club to the National Honor Society, no club seemed as fun and interesting as the South Asian Club. My peers and teacher would educate us club members about their culture, traditions, and favorite media. This is how I found out about Bollywood films and fell in love. In college, I would often listen to music during times of stress or when I was cleaning. Not taking into consideration the musical tastes of others, I played my music openly, only to be met with the distaste of my roommate, who despised Indian music due to the opinion that "Indian people sound too nasal-y" when they sing. Horrified, I realized that in order for me to finish the year out peacefully, I would have to hang out at friends' places or deserted multipurpose spaces to avoid those interactions. I have only the universe to thank for the room transfer that was requested by my first roommate. My next roommate was a Black woman with a distinct eye for fashion, and I was thrilled that I was no longer alone. Sad to say, even though we moved into an apartment together off-campus, I was unable to develop any bond with my roommate, who seemed shy and protective of her private space and time. But I was never shamed for liking things that were important to me, not even my Charlie Brown Christmas tree during the holidays.

During my first years at college, I was hit time and time again with disappointment, and my high expectations were

dashed to the ground. I was hopeful that the diversity showcased by the school to its future students would appear on my path, but it was so rare to find a BIPOC teacher, especially within the theater department. From white teachers asking me to reembody my personal experiences of being assaulted as a child for emotional material to white professors chasing students around the room actively trying to cut their hair off, I became overwhelmed by the realities of the school. In an attempt to find folks who noticed the same things I did, I joined several clubs: Black & Latino Student Association (now Black & Latinx), Spectrum Club (LGBT), and an anime club for which I have lost the name. My goal was to engage with folks who made me feel seen, heard, and respected, and it met my needs to learn more about myself and the world around me from a space of comfort and familiarity. As much as I adored theater, I needed something to fuel the fire building within me, and what could be a more perfect resource than sociology? I began to pick up the language I had been searching for my entire life to label the rampant injustice I had experienced, seen, and learned about. I signed up for many sociology classes as I developed a more nuanced understanding of who built the structures, systems, and institutions that we navigate and for whom they were built. The nearest institution on which to base my assessment was my own college. From the historical paintings of past white presidents to the consistent mostly white cast for school shows, or white school officials justifying their use of racial epithets in their teaching, it became clear to me how many of the institutions in my life continued to uplift and centralize whiteness. I began to feel restless, and it wasn't solely due to the murder of Michael Brown. Nothing seemed or felt right to me since I had become acutely aware of white people encroaching on my space and existence.

My first time sparring with someone over the use of language and trying to educate them about the history and power of words was with my great-grandma. She, a white woman, religiously ate up the *Enquirer*, and though she abhorred FOX News, she still consumed media of questionable sources. One morning, she brought up the protests for justice against the police that were roiling the nation at the time and began calling Michael Brown and those who valiantly fought back against the abusive police presence "thugs." Horrified, I demanded she explain her reasoning, knowing that no reason she gave would be enough to calm me. She responded with the empty and often-used excuse, "When I grew up that is what the word meant." I countered her with facts about the impact of words when it comes to the daily experience of Black men and other people of color in this country, only for her to throw me out of her apartment. Immediately, I called her daughter, my grandma, and relayed the entire conversation and my anger. Rightfully horrified and understanding that I was upset, she validated my feelings and experience by listening to everything I had to say. This was not the first or last time she listened to me as she made herself available to me at all hours of the day. Though the listening ear was helpful, the uncomfortable feeling remained, so I focused on school clubs and my studies with the goal of achieving an intellectual fortitude to prevent being strong-armed when discussing the topics about which I felt most passionate.

In academic spaces, I learned the importance of naming myself. From icebreakers in the classroom to campus events, there was always the moment where I scrambled to attach words to myself so that others would understand me and hopefully share commonality. I leaned on my tried-and-true skill of assessing the data of what was and had been said in

those situations by other students. I realized that folks would often begin with their name, pronouns, hometown, and a fun fact, so I followed in suit. *My name is Ariana Solomon. My pronouns are "she," "her," "hers." I am from California and I'm an anime addict.* This was how it usually went on my part until I realized that there were more options. Some folks used variations of their name or names I did not expect because I had been conditioned to believe that when it came to presentation and expression there were only two options: masculine and feminine. Anime had opened the world of gender bending to me, but I had no clue how gender could be flexed and altered in real life.

I started researching the plethora of available options. Overwhelmed, I decided that even though I was aware of being attracted to people beyond their gender, I needed to understand *my* gender first. Some of the words overlapped with each other, and I felt very uncomfortable settling on one specific word. It was not until joining the Spectrum Club that I heard someone apply the term "nonbinary" to themselves. The boldness of stating that neither male nor female was applicable inspired me. I began to focus on increasing my knowledge of nonbinary people and terminology. *My name is Ariana Solomon. My pronouns are "she," "her," "hers," and "they," "them," "theirs."* Hanging out with non-cisgender people, I learned of the long history of Two-Spirit Indigenous persons who loved and lived on this land long before me. Knowing that there was historical context empowered me to move from "she," "her," "hers" to "they," "them," "theirs." *My name is Ariana Solomon. My pronouns are "they," "them," "theirs."* I knew my gender, but my understanding of my sexuality seemed out of sync, since I had accepted that there were only three options. You were attracted to men or women or both. Well, I just so happened to be attracted to

the first nonbinary person I met. I was absolutely confused because "bisexual" did not seem to fit how I felt about myself. I attended events at school geared toward educating folks on different sexualities and learned that the term "queer" was in the process of being reclaimed by LGBT people after decades of its being used negatively by cishets (cisgender heterosexuals) and the trans folks who confidently upheld assimilation into the gender binary as being the only way. This word held the same energy of infinite possibility that "nonbinary" held for me. *My name is Ariana Solomon. My pronouns are "they," "them," "theirs," and I am a queer person.* That freedom to claim myself on my terms with words that I had researched and chosen for myself was akin to meeting myself as a person for the first time.

I decided that I needed a journey to find out more about myself while also learning about the world. If I changed the environment in which my true self was born and celebrated, I would then be able to clear the internal hurdles of self-acceptance. Thus, I set my sights on going to Japan for a study-abroad experience. I knew that my chances of getting there after college would be slim, so I shot for the moon and applied and was accepted during my junior year. Since Japan is a homogenous society that celebrates fair-skinned folks who fall firmly into femininity or masculinity, I worried I would stick out as a sore thumb. Deciding it best to be forthright about gender and race, I sent my first letter to my host family including my new understanding of myself. I attended the program with great expectations. Firm in my gender expression, I thought I had conquered my only hurdle. Instead, what tripped me up was the fact that I appeared neither Japanese nor white. I could see how other white foreign students seemed to have an easier time when engaging with

Japanese people. Meanwhile, I could feel eyes staring at me all the time and was aware that I lacked the bond I had wanted to form with my host family during my stay. It was as if the local students felt a greater level of comfort and conversational ease with the white foreign students. Even when I dressed masculine and adjusted my makeup utilizing dragking concepts, I felt the isolation increase until I began attending the LGBTQ club of Sophia University (Jochi Daigaku). I floundered my way into the LGBTQ club until I met the president of the club, Kan Kikumoto. It was then that I felt seen and included. Kan, my *senpai* or older classmate, was a valuable friend and support system during my stay in Japan due to his kind heart and awareness of the issues brought up during international experiences. I will never forget that he was one of the few people during my trip abroad to consistently use my correct pronouns. The only other comparable relationships I formed were with politically likeminded people who, although they did not use my pronouns correctly, never pressured me to conform. They saw and accepted me as I was while holding no expectations.

Even though my friends in the program were supportive, I commonly encountered many Japanese people who held negative expectations about me, often rooted in their own social values. Americans have been classified time and time again as loud, crass, overeaters, and messy. Being the American that I am, I hit all of these on the head while trying to be selective as to when and where. Acting loud and crass on a night out or eating a huge meal after a long test was my way of being true to myself. I even consolidated my mess of a suitcase, where it could be zipped out of sight (I overpacked). However, the social etiquette of Japan left its imprint upon my behavior. I learned to gauge the responses

and body language of others and not be forceful with my requests. Being proactively considerate of the needs of those around me became a pillar of my behavior, and the foundation of my childhood technique of not making waves as a survival method eased this transition. Taking it too far, I began to minimize negative interactions by attempting to homogenize. Toward the end of my stay in Japan, I began to straighten my hair more often with the reward of fewer hands finding their way into my hair, and my hair finding its way into the conversation less and less. When my style of dress leaned feminine, I had fewer painful interactions or feelings of exclusion. Afraid of conflict and isolation, I chose to adapt myself to be more palatable to others. I chose to pass.

Passing felt like I was wearing a mascot costume, while inside I was still the same loud BIPOC who sat with their legs open and their heart on their sleeve. I hated dressing as if I was a cis-woman and I hated carrying my flat-iron. It wasn't until late at night on a friend's birthday that I realized how untrue I was being to myself. I was outside a bar with another student in the program. We had been hanging out as a group but had gotten separated. Deciding to stay in the same area after texting and calling our friends, I could think of nothing but kissing her. As we moved closer together, it became clear that I was not the only one with fever on the brain. When we kissed, I stopped caring if and how our friends would find us. It wasn't our friends that stopped us, but some of the local business owners who were hanging out at the entrance of their businesses. I spent so much time adapting for a smooth experience that my pent-up frustration built up and we returned to exploring each other's taste and softness. All I cared about was more of her

lips, smell, and roaming hands. It was only due to a text from our missing friend that we stopped and returned to our original quest. By remaining true to my individual wants and desires, I momentarily tapped into the power and joy of authenticity. Shortly after this, I began to travel more freely to different locations around Japan either with friends or by myself, as myself. From long dresses to button-up shirts to pair with my hair curly, straight, up, or down, I began to ask myself what made me feel real and true. Fearfully gleeful in this new power to choose myself, even during a moment of fear and perceived isolation, I began to put my wants and desires ahead of those around me.

As I leaned into this new power, I noticed folks seemed to be drawn to my authentic self rather than the heavily self-edited, trauma-informed version that I had been cultivating for the sake of others. When I returned to the United States, I decided to continue with this same energy. Empowered, I began to prepare for my final semester of college by seizing opportunities anywhere I could find them. Many peers I talked to explained that they already had a job lined up or were going to transition from part-time to full-time at some esteemed organization or company. The things that most of these folks had in common were their palatable whiteness and conforming gender expression. Not noticing this immediately, I applied repeatedly and was rejected or flat-out ignored each time. I sent follow-up emails and informational interview emails only to receive nonreplies. Those same voices in my head that I had thought vanquished shouted, "Your resume isn't good enough and neither is the person applying." I had just gotten in the swing of doing me, while in my peripheral vision the door to conformity sat ajar from my last visit. If I opened the door, I would have one less

thing working against me, but in exchange I would have an additional thing I would need to hide from the interviewer. Deciding to take the honest path, I continued to apply, but after more rejections than I can count, I shifted to focusing on finishing the year strong. I spent most waking hours on campus, working on final presentations, performances, and thesis papers. As my list of to-dos steadily decreased, my frustrations with the campus itself increased at a more rapid pace. Worried that I was going to leave it the same as when I first walked in the door, I began to join student activists who were making waves with a nonviolent, informative, activist approach. Years of sociology lectures lent me the foundational language and understanding of history needed to fuel my desire for change. From informative flyers to missing bathroom signage, I laid my mark upon the community, hoping that those like me who came after would benefit from the changes, no matter how small.

Thankfully I was not alone in these desires and realized that folks with shared understanding create bigger waves than those who work alone. I began to be selective of friend groups, prioritizing folks who shared my disillusionment and discontent, and if they were BIPOC and queer, then the connection was even stronger! Though my great-grandmother was in visiting distance, I needed folks with whom I could relate on all levels. The collective passion, motivation, and support I felt from these friends were so intoxicating that I wanted the same experience everywhere and for everyone, including the person I happened to be dating. I was confident in the community I had found, my recent successful trip to Japan, and my desire to boldly express my gender and claim the pronoun "they." Assuming that he would be supportive, I decided to come out.

Unsuccessfully.

Painfully.

After a lecture about my being brainwashed and severely lacking in mental stability, I felt as though I was once again alone. This person who had affection for me held no compassion for the newly out nonbinary person standing before them. Instead, there was only a never-ending, oft-repeated list of every way I came up short as a partner and a human. Unable to imagine a future with this person, I ended things shortly after.

Swearing to myself that I would hold tight to my values, I found myself forced to disclose who I was to move forward with any relationship. I was fearful that informing a potential interest too late could turn deadly. I was grateful to have skipped that scary and unpredictable introduction to a relationship by dating a very good friend whose experimentation with presentation always made me feel seen. Unfortunately, we realized that the relationship was at too high a cost to our mental health, and with varying success, I dated several more people until meeting my current partner and his now ex-fiancé. Excited at the opportunity for a possible threesome, it wasn't until we were all in bed that I felt comfortable enough to request that the pet name "Princess" that they used for me be discontinued. I meant to have "the conversation" about this earlier on but could not find an opening. The feminine association of the pet name had the opposite effect on me, considering where the three of us were heading. I am so lucky and grateful to say that when I came out in this most vulnerable way (naked), I was respected and heard! Clinging to them, I found comfort in knowing that I was being treated with all of the love, respect, and kindness that I had been searching

for my entire life. The days went by filled with flirting, laughing, and dates, but just as quickly as it all started, they came to an end. When the couple decided that they would no longer continue forward with their wedding engagement, I was once again overwhelmed with confusion. Giving them space seemed like the right thing to do, but instead I ended up spending even more time with the person who stayed constantly in contact with me. Refusing to let go of someone who saw me as the BIPOC Trans Nonbinary Queer I am, I opened my door to the still-interested half of the couple, Andrew.

As we grew together over the years, I found myself often weighing the pros and cons of the relationship. We loved each other and desired to share a future together, but his family would never be what I hoped for. With each visit, the misgendering hit me harder and harder into the back of the closet. The racial microaggressions weighed on my mind until, in a fit of rage, I would barrage my partner with questions, demanding a reason as to his inaction, his silence. Coming full circle from my childhood to adulthood, I find myself participating from the outside in just as many aspects of life as I did then.

No moment made this clearer in my life than January 1, 2021.

My one connection to my past, my trauma, my suffering, and my childhood died. My brother had fulfilled the dooming prophecy spoken about us by adults who came in and out of our lives. It was as if they were rooting for one or both of us to meet an early demise, and to be the surviving sibling fills me with overwhelming pain and grief. I knew of his struggle with addiction and had hoped that the measures he and his mother (my grandmother) seemed to be taking would

extend his time on this planet. To lose someone who is bonded to your soul prior to toddler years is hollowing. When his mother first told me, I screamed out my pain for hours until I fell asleep. Upon waking, it would only start again. Unable to operate in daily life during this period, my partner Andrew stepped up for me in ways that had been unknown to me due to my childhood experience. Handling communications with my job, ensuring I was hydrated and fed, and sitting with me were only some of the ways that he reminded me that what I was feeling was okay and normal. For months I couldn't look at anything normally. Everything was immediately associated with a shared memory.

Many months later, I decided that I wanted to be more of an active participant in my life again. Losing my brother reminded me that our time alive was short and, in Marsha P.'s words, "nobody promised you tomorrow." I decided to focus on music, food, art, and establishing the boundaries that allow me to be my authentic self. The last was the most difficult. I had many chances to exercise my desires but typically felt unempowered to say anything. One such time, I posted a photo of myself on Instagram celebrating an outfit that defied the gender binary. During my moment of euphoria, I was bashed over the head with dysphoria when I opened my post notifications to see that I had received a compliment from my partner's father in which he'd misgendered me. Frozen and unable to react, I waited until my partner awoke to inform him of the incident. We discussed back and forth what it would take to make it right. Though I had asked for Andrew's intervention several times in the past several years, I was worried that his suggestion of sending a text to his father would merely point back to me. But the text was sent, and a reply was received. And to my surprise it

was an apology and a promise to do better. This small text that had been sent out into the void returned to relieve me of the burden of making my true desires known. Sobbing with relief and joy that my partner backed my identity, I listened as he whispered, "If a person is not invested in who you are, their preconceived misconceptions have no power in limiting who you are, nor your capabilities."

Epilogue

Androgyny and Other Forms of Nonbinary Race

STEPHANIE HSU

My race is my gender, as an androgynous Asian. This is a racist stereotype that originates in an orientalist division of the world, but it's also the body image that holds my queer desire. It's interesting that the East/West binary, unlike other racialized binaries, should result in an androgyne: the emasculated, effeminate, sexually deviant, or desexed Asian body. Asian androgyny is a product of the imagination, a visual or sensory attribution made to bodies that share histories of resisting colonialism and imperialist aggression; of indentured or immigrant labor in the Americas (often a gender-segregated existence); of media representation as the exotic or perpetual foreigner, if not the wartime enemy; and of social assimilation into other racialized binaries such as Black/white and Indigenous/settler, making anti-Blackness and anti-Indigeneity the conditions of our

modern personhood. Just as there was once a Near, Middle, and Far East, Asian race is a spectrum of hues and the outcome of both imperialist conglomeration and intentional panethnic coalition.

The Asian androgyne can be imagined by anyone who desires this body, and so I'm nonbinary even (or especially) when I'm not there. In fact, I'm often summoned to the page by queer and nonbinary writers in the form of references to nondualism, reincarnation, and other Buddhist notions. There's also this insightful theorizing by Riki Wilchins in the inaugural anthology of its kind, *Genderqueer* (2002): "Confined to what is not-man—sex, procreation, and mystery—Woman is always genderqueer. In terms of color, this would be *equivalent to Asian being racially queered*. Asians are seen through the lens of Orientalism. What is Western and white is universal, while the Orient as Other is confined to the mysterious, exotic, and primitive."[1] There's nothing more about what this equivalence might mean, or how racial queering intersects with genderqueering, or why the Orient is a term of color. Wilchins's playing with categories, however, is certainly characteristic of nonbinary thinking, starting with their renaming of the man/woman binary as man/not-man. Nonbinary methods attend to what's both, between, or beyond, according to Meg-John Barker and Alex Iantaffi, and involve "shifting our framework away from a rigid either/or perspective, towards both/and possibilities, which embrace paradox and uncertainty." This is the only way to anticipate and avoid the creation of "a new binary between non-binary people and binary people (men and women)," or the ultimate form of the "binary/non-binary binary."[2]

What can nonbinary thinking teach us about the persistence of racial binaries, or the ultimate form they might take? The personal stories in *My Race Is My Gender*

demonstrate that recognizing nonbinary gender can also exercise and train the vigilance that antiracism requires. In this epilogue, I'll explore some nonbinary moments in critical race, queer, and trans theory and literature, and in my own life as a queer Asian American academic, and I'll consider how nonbinary ideas and methods can support racial solidarity work. If any binary is first a negation, as man/not-man illustrates, then East/West would seem to intersect with the white/non-white binary, furnishing a basis for coalition among people of color (or POC) that's increasingly called Brown. As an androgynous Asian dreamed into being on this divide, however, I confess POC is a notion that too often hides the lack of relation between racialized communities, as well as the existence of an ultimate binary. Asian North American scholars have used terms such as "intermediary race" and "racial triangulation" to describe our racial positioning in the modern world after the African slave trade.[3] Perhaps it takes this third vantage point to see that the primary and enduring negation in a world structured by white supremacy isn't white/non-white, as some analyses of anti-Asian racism would suggest. Rather, the ultimate binary in a world with race is Black/non-Black, and anti-Blackness is the fulcrum of raced gender—yours and mine.

> People are never shy to ask about a dog's gender and are quick to apologize when they get it wrong. Yet when it comes to the human species, directly inquiring about a person's gender is often considered egregiously offensive. Regarded as almost insulting is the act of accidental misgendering, like calling someone *sir* when it should be *ma'am*. In this situation, a casual apology is not the norm; instead, the guilty party usually fumbles through a fix, thoroughly embarrassed by this transgression.[4]

How strange to read this scenario in the opening pages of another collection, *Nonbinary Memoirs of Gender and Identity* (2019), and realize all the apologies I've been owed. Misgendering usually doesn't trouble me as a self-identified androgyne, and I've learned to expect it from strangers ever since a serendipitously bad home haircut by my mom in middle school helped me discover that my gender, my ideal self-image, is a tightly coiled spring. They may flinch upon hearing my American accent and high-pitched voice, but the casual stranger doesn't say "Sorry" for calling me sir, and I can hope that cognitive dissonance is teaching them not to gender people so quickly, but I'm pretty sure their lack of embarrassment means they don't care. While wearing a mask in our pandemic times, I've noticed it happening to me more, even on the part of healthcare workers who have my medical records in front of them. Sometimes, the social graces are suspended entirely, people stop talking to me altogether, and herded along by gestures, I fall out of language and feel the gears of racial formation grinding around me again, compressing my body into a less recognizable shape.

A beloved of mine used to remind me that body shape is one of my relative social privileges, in addition to being Asian while he's Black. I knew this to be true every morning I helped him struggle into his chest binder, though the freedom to breathe is one you can't feel until it's constricted. When he decided to come out as trans at work and to his family, I started identifying as genderqueer without changing much but my language, because association with the words I used then, such as "lesbian" or "girlfriend," could cause him as my partner to be misgendered. Coming home late at night from queer parties in the bars and clubs, we'd both slouch in our subway seats, throw wide our legs, and pull our hoods up, trying to blend in with Black, Latine,

and Asian men also headed home after closing time, or perhaps headed out for an early shift. Me in careful imitation of that masculine stonelike fatigue I recognized from growing up around restaurant workers, and out of care not to draw attention to the two of us because he'd been chased down nighttime streets before, but also a little ashamed for being unlike all of them.

There's apparently an ideal form of the nonbinary body, even though the possibilities for being not-man are expansive: "The visible face of non-binary gender tends to be young, white, slim, masculine-of-centre or androgynous, educated middle class, and not disabled. The identity is therefore more difficult—or unwanted—to claim, the more a person sits outside of this privileged group," Barker and Iantaffi write.[5] The representative face of the movement would be me, but for one big reason. That's what it means for Asianness to be adjacent to whiteness in a structural sense, even though it's a dubious privilege because not all Asians want to be seen as androgynous, and misgendering can only partially name our injury, since racist stereotypes have overdetermined our gender appearance.

The possibility of receiving an apology that can restore you to your proper human gender is a species-based distinction, according to the editors of *Nonbinary Memoirs*, Micah Rajunov and Scott Duane, because sexual difference, or fitting into the symbolic scheme of sexual reproduction, is understood as the first law of being human, and it's the basic social norm that queers transgress. Because "nonbinary people reconcile with an inner gender that cannot be properly expressed and understood by the outside world," Rajunov and Duane continue, "very often, their true identity can never be fully actualized."[6] But what is this true identity? When I choose to tell strangers that "I'm not a sir," I'm not trying to

posit how I truly identify as much as I'm demanding more humanizing interactions on behalf of all Asian bodies. When Wilchins claims that all Asians are racially queer, just like all women are genderqueer, they aren't positing specific identities for Asians or women as much as observing how people assigned to the subordinated or negated side of a binary are denied the possibility of self-determination.

One way to deconstruct a binary is therefore to reveal its artificiality by finding new meaning (e.g., genderqueer) in what's been negated (e.g., not-man). Another strategy is to propose a broader category that can subsume the binary, which often results in a universal version or vision of humanity. For instance, Andrea Long Chu (who does *not* identify as nonbinary) has delightfully argued, "Everyone is female, and everyone hates it. . . . Gender exists, if it is to exist at all, only in the structural generosity of strangers. . . . You do not get to consent to yourself—a definition of femaleness." Chu explains that her notion of femaleness is "ontological, not biological," and it corresponds to "a universal existential condition, the one and only structure of human consciousness," because our desire for recognition from each other makes us interdependent. If sexual difference is binary, then we're all on the same side as products of existential violence in a patriarchal society. "If this is true," Chu concludes about female-hating, "then gender is very simply the form this self-loathing takes in any given case."[7]

Gender, whether binary or not, always gives expression to the self/Other binary, which is a relation that can be menaced by misogyny, transphobia, and external or internalized hate in other forms. The shame we're made to feel for disrupting gender conformity is a symptom of our collective repression under binary gender, but these reactions to nonbinary gender prove that even the self/Other binary isn't as

fixed as we might think. As Alok Vaid-Menon declares, "There are no such things as gender non-conforming issues; there are just the issues that other people have with themselves, or rather, the issues that they *have with themselves that they take out on us*."[8] Whether as scapegoat, martyr, or prophet, the nonbinary Other serves as a vehicle for anyone's self-definition or self-actualization. As Jeffrey Marsh writes, "I'm a metaphor for being free, for a grander ideal. I am a walking, breathing representation of the fruits of self-acceptance. I represent one idea and one idea only: how to be you. . . . I represent a freedom around gender, an idea of freeform identity, and people hate me with enthusiasm."[9] Nonbinary freedom doesn't necessarily abolish gender, but rather expands it into an individualism of the purest form, where self can recognize self (an intimidating prospect, indeed).

But what if gender isn't the universal binary that divides us as humans? How else do we explain the hate at the center of our lives? In counterpoint to the arc of nonbinary thinking I've just traced, Patrice D. Douglass puts it very simply: "While there is no place in history where all women have stood subjected equally to violence, there is such a place for the black, the hold of the slave ship."[10] Dehumanized by enslavement and the mortifying accounting systems applied to chattel flesh, which broke every human law of kinship and culture, black bodies reached a "zero degree of social conceptualization" and became "ungendered," in the words of Hortense J. Spillers.[11] In fact, "the ungendering of blackness is also the context for imagining gender as subject to rearrangement" at all, as C. Riley Snorton has concluded about the historical fact of Black transness.[12] The new binary that emerged when all the others were broken is what theorists of Afropessimism name as Human/Slave, and this difference

is irreconcilable: for one to have meaning, the other must persist. Compared with the notion of "freeform identity" proposed by nonbinary white writers, there couldn't be a starker contrast.

A long-standing disposition within Black thought, Afropessimism was given a name only recently, alongside the global refrain that Black life matters. "By focusing gender through the scope of death," Douglass explains, "the point is to refuse binaries and dichotomies, and widen the scope of engagement to think about gender within the broader political concerns of Blackness as a political ontological category."[13] Ontological, not biological, which here means that Blackness is assigned to a great many bodies within a global society whose idea of the Human still depends on the idea of the Slave. A critical insight from Afropessimism is that anti-Blackness can't be effectively defined because it's coterminous with being Human, so there's no "grammar of suffering" or descriptive language that can fully express or expose the systemic racism permeating modern life.[14] An example of this problem is the "trap door" that media visibility presents to trans people of color, as Tourmaline and her collaborators have observed, since the celebration of trans and nonbinary celebrities in popular culture has paradoxically done nothing to reduce reported violence especially against Black and Latine trans women in North America.[15]

Although nonbinary gender also defies any singular definition, the contributors to *My Race Is My Gender* share ways of describing daily and systemic threats to our safety and dignity that can be summed up as intersectional oppression, a concept created by Black feminist theorists such as the Combahee River Collective, Audre Lorde, and Kimberlé Crenshaw. Intersectionality names as a problem the fact that when

nonbinary people of color are used, hurt, invalidated, rejected, violated, or shamed even inside our own queer communities, we tend just to call it racism, defaulting to a binary of oppressor/victim that usually centralizes the role of whiteness and prevents us from thinking about anti-Blackness as a specific form of violence that has shaped every human gender. Our portraits in this book are mirrors in this crucial sense, reflecting back a world in which the Black/non-Black binary can be glimpsed in the image of our nonbinary genders. In this Black/non-Black world, nonbinary race means that our race is our gender because racism manifests itself as often violent misgendering, and gender recognition is impossible without racial reparation.

I was assigned female at birth in a Southern town (on Muscogee land) when its famous golf course was still segregated by race and gender, and my family worked in both of its Chinese restaurants. Once our savings went into the failed venture of a gift shop named Si-Am Oriental Arts, as in "Sino-American" (a term that preceded "Chinese American") but also as a trick for the romanticized Kingdom of Siam (now Thailand), which was characteristic of my grandfather's wordplay (in any language, it seemed). Of this shop I have the vaguest impressions, such as clacking strands of curtains beaded with Polynesian nut shells and perhaps a bell on the door that rarely tinkled. Nowadays, I'll unearth an old cardboard box at my father's house that's filled with treasures, like a dozen fine brush-painted eggshells in glass cases or brass incense burners in the shape of a genie's lamp, and I'll marvel at my grandpa's outsized hope in a Southern town's taste for the exotic. It was a relief to me as a teenager when "Asian" began replacing "Oriental" in mainstream dialogue, which I could justify by saying that "oriental" is an adjective

meant for objects, not people. I felt the difference in grammar: a literal human, not a gift unaccepted. After the shop folded, my dad went back to restaurant work for the next thirty years.

Assembled from all over Asia and the Pacific Islands, the gifts that bankrupted my immigrant family's business were beautiful objects that sublimated the violence of colonization and war. While Orientalism is the name for this centuries-long tendency to romanticize and sublimate the opposition between East and West, Anne Anlin Cheng has developed a theory of "ornamentalism" to describe the "transference between things and bodies" that increasingly characterizes Asian racialization under global capitalism. As ornament, accessory, style, or decoration, Asianness can be signified by things that anyone can buy (or not) to adorn their own body or space. Ornamentalism is therefore an "alternative American racial logic" for maintaining white supremacy that points to a "divergence between black flesh and yellow ornament" in our racial psyche. The "yellow woman" is its icon, though "yellow" is a reclaimed term from the nineteenth century that's rarely used these days, and like the proverbial China doll or the imaginary androgynous Asian, "she represents feminine values but is often not considered a woman at all." Because the violence of her own objectification is wrapped up in the commodification of her culture, the yellow woman seems to display an "ontological shallowness" that corresponds to "when one treats oneself like a thing," albeit a beautiful or desirable thing, which still amounts to an "aesthetic privilege," Cheng says.[16] In contrast to the ontology of the Slave, which for humans is an unthinkable state of nonbeing, the yellow woman is part human, part object, and this partial or shallow existence can invite others to imagine taking her place.

Consider, for example, how Kate Bornstein draws on Asian religions to describe the value of queerness and gender radicalism in *Gender Outlaws: The Next Generation* (2010). "At its best, it's the concept of Bodhisattva: the conscious decision to re-incarnate as a lower and lower life-form lifetime after lifetime so that when you finally do attain enlightenment, the radiance will reach all sentient beings everywhere. Apply that to one lifetime, and that's what we do. At our noblest."[17] More than an analogy to Buddhism, Bornstein's reflection on the extraordinary toll of surviving trans and nonbinary oppression utilizes reincarnation and the idea of delaying nirvana to explain how gender nonconformity involves sacrificing your social privilege—which seems optimal when you hold white power, or a position in a hierarchy that readily assumes there *are* human life-forms lower than yourself. By making Asian spirituality serve this implicitly racialized worldview, Bornstein's explanation inserts yellowness into the hierarchy as a "noble" position of downward social mobility that anyone can choose to occupy. Gender radicals are thereby given a yellow ornament that helps us to wear our oppression with pride.

In nonbinary thinking that invokes the East/West binary, I most fully discover how my androgyny can be both an aesthetic privilege and an alienating outcome of racial discourse that turns me into a part-object amid objects, to paraphrase anticolonial theorist Frantz Fanon. What makes this kind of cultural objectification possible, however, isn't my race but my ethnicity, which is a property of the Human that consists of everything the Slave is denied: for instance, the language, traditions, and knowledge of your ancestors that's meant to be shared, like the universal welcome of Buddhism. Yellowness is a concept Cheng mobilizes to remind us that "*alongside* the black

enslaved body, we must also consider the synthetic Asiatic woman" on a spectrum of race and racism.[18] Another way of describing this nearness to Blackness is brownness, and in the work of José Esteban Muñoz and others, brown becomes the idea of proximity or relation itself. "Brownness is a being with, being *alongside*," Muñoz offers, as a way to theorize a posthuman or ecological "commons of brown people, places, feelings, sounds, animals, minerals, flora, and other objects. How these things are brown, or what makes them brown, is partially the way in which they suffer and strive together but also the commonality of their ability to flourish under duress and pressure."[19] Brown might now be synonymous with people of color in the formula of Black, Indigenous, and People of Color (BIPOC), but if white supremacy is our common enemy, then brownness could also encompass white people in representing a universal human condition or ontology that's one with the suffering or flourishing of our planet.

"Unlike whiteness or blackness," Amardeep Singh observes, "Brownness can continue to grow and evolve."[20] This expansive possibility is what I want from gender diversity, but brown and nonbinary aren't so easily compared with or analogized to each other, because this isn't just a thought exercise: people who identify as brown and nonbinary (and Buddhist, for that matter) do exist. Personally, I don't call myself yellow or brown, because while "POC" certainly works to resist and reclaim the subordinated half of a white/non-white binary, it's also become an approach to racial identity that perpetuates a Black/non-Black binary in ways that are hard to recognize and more difficult to talk about.[21] The difference between race and ethnicity is one way in which this unspoken Black/non-Black binary has been understood politically, as Susan Koshy highlights when she predicts that

"new ethnicities identified with the new needs of the global economy will accrue greater cultural capital, and their achievements will be used as an argument to roll back civil rights initiatives and as evidence that the racial problems of the 1960s have been resolved."[22] Through Asian and Latine immigrant success stories that bolster the American Dream of meritocracy and bootstrap capitalism, "brownness converts blackness into unquestionably shareable no-longer-blackness," as Ren Ellis Neyra puts it.[23] Ethnicity and access to our cultural heritage may even offer us non-European traditions of nonbinary gender roles and expressions that can support our daily struggle to feel at home in the world, but what transforms panethnic identities into races in North America isn't an immigrant experience or even a shared precolonial past—it's the "psychological compensation of nonblackness," in Koshy's words.[24] In a society where Asians are called yellow, brown, and white, sometimes I'm a person of color, and sometimes I'm not.

"You know you're fish, right?" In Kai Cheng Thom's groundbreaking *Fierce Femmes and Notorious Liars: A Dangerous Trans Girl's Confabulous Memoir*, a young Asian runaway receives this compliment from her Black femme mentor. Our unnamed Chinese Canadian narrator can't believe it and confesses, "I laugh because while it is true that I am small and hairless and have a neat little face, I am also flat chested and have oily skin and thick hair that cannot be tamed. To me, *fish* means *beautiful*, means *glamorous*, means *doesn't look trans*." While writers of Asian descent will often describe ourselves as androgynous, I've noticed that only in trans literature is our androgyny unequivocally celebrated or valorized. "Fish" is a term that originates in Black and Latine queer and trans culture, and in Thom's memoir, it also

signifies the Asian body's relative ease in transitioning, as the older Black femme character explains: "You may not want to see it . . . but you were born to a certain privilege," Kimaya teaches her newest Asian sister, such as "being able to walk in the daylight . . . without fear of being chased and beat up by somebody or arrested by the cops," maybe getting a job that's not sex work, or finding an "uncomplicated, wealthy" boyfriend, "and I want that for you," she affirms. Checking her reflection again, the narrator now realizes, "My hair, which I have always hated, is not just thick, but lush and shiny and starting to fall in waves past my chin. It frames my tilted eyes, which are almond shaped and long lashed, and my slanted cheekbones. . . . And I think about how Kimaya is right, how *fish* means opportunity and privilege."[25]

Thom's fantastical memoir describes the moment that Asian androgyny is transformed from liability into asset, from a source of self-hate into an image of beauty, glamor, and success. "Fish" names an aesthetic privilege that our Asian narrator can't see, however, until Kimaya is literally holding the mirror to her face. This is "the black femme function," or the purpose of "a figure whose invisible, affective labor ensures the survival of forms of sociality that were never meant to survive," says Kara Keeling in an echo of Audre Lorde's poetic line. In the spirit of queer of color kinship, what Kimaya supposedly wants is for the narrator to grow self-empowered, but the Black femme's caregiving function here—her capacity to serve in our imagination as the mirror inverse of social privilege—is "an affectivity of slaves," as Keeling has put it.[26] The affectionate relationship that's assumed between Black and Asian femmes in this story also reflects "the political desire of non-blacks for coalition with blacks," in Jared Sexton's words, and we can tell that this

desire for Blackness still belongs to the emotional economy of slavery, Sexton warns, because we expect that in "the imaginary of this interracial political romance, black rage converts magically into black affection."[27]

As for magical transformations, this makeover is also the moment that the Asian subject's gender becomes her race: a literary depiction of intersectionality that can only be viewed in the mirror of Blackness. Out of what seems like a protean state of androgyny (small, hairless, neat, flat, oily, thick), our narrator grows beautiful through the very conventions of representation that racialize her as Asian, which are focused on the face and especially the eyes (tilted, almond shaped, slanted). There's an impoverished set of terms used to describe Asian bodies, including "yellow" and "moon-shaped," and I can't think of any adjectives (in English) that aren't in fact applicable to all genders. That's because Asian gender difference just seems less important or informative to the dominant gaze than Asian racial difference is—not from whiteness, but from Blackness, as Thom's insightful narration shows. Even while conceding that Kimaya is right about how aesthetic privilege is unearned, our narrator insists that her Asianness is just physical or morphological, not political or ontological; a matter of hair texture and facial structure instead of social and economic structures; and an unsought opportunity to benefit from whiteness rather than a direct investment in anti-Blackness. The kind of magic that makes Asian androgyny not only beautiful but necessary to the symbolic codes of white supremacy originates in just such a massive repression of anti-Blackness, or (anti-)Black magic, indeed.

Consider how Roland Barthes describes the Japanese face, almost a half century before Thom: "Not on this surface but engraved, incised within it, the strictly elongated slit

Epilogue 119

of the eyes and of the mouth. The eyes, barred, unhooped by the straight, flat eyelid . . . debouch directly onto the face, as if they were the black and empty source of the writing. . . . This writing writes nothing (or writes: *nothing*)." With inkwells for eyes, the Asian face is a blank page for writing "nothing" or 無, a word that's *mu* in Japanese (or *wou* in Chinese, as is later important to Barthes) and which, printed in thick brush strokes of sumi ink that delicately feather at the ends, occupies an entire page in *Empire of Signs*, a book he composed as a French tourist to Japan in the late 1960s.[28] The nothingness of the Asian face is the potential for its gender to be determined by the desire of strangers, as Andrea Long Chu has put it, and this characteristic blankness is what makes the Asian body into an aesthetic object, as Anne Anlin Cheng has argued. By Barthes's description, the shape of the slit that characterizes the eyes and mouth is also vaguely genital and suggestive of a sexual receptiveness in the Asian body, which becomes a site for his fantasy of "pure difference." Exemplifying this purity is the figure of the "Oriental transvestite," as Barthes describes the Kabuki theater actor whose photographic portraits both in and out of traditional attire are among the many images of Japanese subjects (mostly unnamed men) included in the pages of *Empire*. Barthes has high praise for this actor who "in his face, does not play the woman or copy her, but only signifies her" through "the gesture of femininity, not its plagiarism," which is how he disparages drag performance in the West by comparison. As the "pure signifier" of woman, the Kabuki actor is very fish.[29]

Racism and transphobia reinforce each other in Barthes's extended metaphor about writing and gender: if transness is an unauthorized copy of femininity, then Asianness is a text of "nothing" or a record of disavowed attraction, and Barthes's

readers have connected such convoluted statements of desire to the open secret of his queer sexuality, carefully guarded during his lifetime. Like beauty in the eye of its beholder, androgyny is an attribution that comes from the Other, but whether fish is compliment or insult seems to depend on whether this Other is Black or white, when you are Asian. Triangulating these perspectives suggests that the condition of being an androgynous object of white desire—a symbolic blank—is only imaginable as a livable or perhaps even desirable condition when compared with the condition of being Black, like Thom's character Kimaya. Against the presumption of queer and trans of color solidarity and kinship, Calvin Warren therefore wonders if violence against Black queers can be recognized by other queers as anti-Blackness at all, and he refers to this redoubled ontological violence that we commit against Black queers as "onticide." If Asians are structurally queer with respect to dominant social binaries (e.g., Black/white, feminine/masculine), then it follows that the "'Black Queer' does not and cannot exist," as Warren declares.[30] Queer theory and Afropessimism may therefore be at odds, but could it be that the grammar of Black suffering and the writing of Asian optimism are one in the same?[31]

"We need to understand," Frank Wilderson urges, "that anti-Black violence is not like anything else: these are rituals of pleasure and psychic renewal for the Human race."[32] What renews Asian androgyny as a ritual of (mis)recognition that's sometimes desirable, sometimes not—and what does it in turn renew? What meaning or resource has nonbinary culture found in Asian androgyny, and how much Black queer onticide has been committed in the process—and how do we even stop? After his captivation by the East/West binary, Barthes turns about a decade later to the

consideration of all things nonbinary in a late set of his lectures, posthumously published as *The Neutral*. A free association on the concepts of neutrality, the neuter, and "every inflection that, dodging or baffling the paradigmatic, oppositional structure of meaning, aims at the suspension of the conflictual basis of discourse," this text presents cultural examples that elude our binaries and defy the logic of negation that secures them, but which therefore also suspend our desire to know, define, or settle on what's truly nonbinary. The role of the androgyne in ancient religion and mythology is discussed in the final chapter, but the penultimate lecture is dedicated to the Daoist concept of *wou-wei* or nonaction, which Barthes elaborates as the ethical act of opting "not to choose" when confronted with a binary opposition. Here, there's no more mention of the *mu* or nothingness of Asian faces that can be any gender you want, or the fishiness of Asian bodies that can convey the fantasy of pure difference. Rather, having seemingly sublimated any racial desire, Barthes concludes that the attitude of remaining neutral is "a manner—a free manner—to be looking for my own style of being present to the struggles of my time."[33] Inspired by an Asian face he once knew, what can this wish for freedom be—what else can it mean, for me—but the dream of neutrality in an anti-Black world?

Nonbinary gender is often described in terms of this transcendence, as the leaving behind of certain inherited ideas about social roles and behaviors in order to invent, re-create, or recall more livable ways of holding desire in our bodies. The voices in *My Race Is My Gender* declare, however, that the intersectionality of our identities isn't something to be transcended, because the symbolic terrain of nonbinary gender is already full of racial, ethnic, and other meaning. In recent years, the invention of the term "enby" in online

communities as a shortened way to refer to nonbinary gender identity—because the abbreviation NB already names the position of non-Black people of color (NBPOC)—proves again the silent gravity of the Black/non-Black binary and reminds us that white supremacy doesn't need white people for it to function at all. Although nonbinary gender has been associated with transcendence, neutrality, personal freedoms, and other humanistic ideas, it turns out that nonbinary thinking can reveal as much about the position of the dehumanized or nonhuman, if only we learn to recognize this other face.

When your race is your gender, to be antiracist means being truthful about your desire, not just acknowledging where it leads you but also admitting where there's a lack of relationship, an untried or unreturned overture, or even an anti-relation—that is, a desire that's been keeping us apart. This book's contributors share an intensity and a clarity of perception and language for describing the frequent breakdowns of racial solidarity which have only made it more vital for us to treasure and tend to our nonbinary selves. The conversation we've tried to create about how anti-Blackness shapes our queerness gives us a chance to become chosen, if sometimes estranged kin to each other in a world that we don't always want and often can't believe. The magic we therefore seek in writing, photography, performance, theory, witchcraft, activism, drag, plushies, cruising, chinoiserie, the oceanic, a *senpai*, a *semisaki*, the extraterrestrial, and more—it's not the kind of magic that transforms rage into affection, to echo Jared Sexton, or that presumes an easy solidarity over shared interests. Rather, it's the perpetual power of the nonbinary to reveal limits and expose hierarchies that unites us in our desire to see the Black/non-Black world for what it is, starting with portraits of nonbinary race.

Notes

1. Riki Wilchins, "A Certain Kind of Freedom: Power and the Truth of Bodies," in *Genderqueer: Voices beyond the Sexual Binary*, ed. Joan Nestle, Clare Howell, and Riki Wilchins (New York: Alyson Books, 2002), 44, emphasis mine.
2. Meg-John Barker and Alex Iantaffi, *Life Isn't Binary: On Being Both, Beyond, and In-Between* (Philadelphia: Jessica Kingsley, 2019), 16, 74, 75.
3. See Susan Koshy, "Morphing Race into Ethnicity: Asian Americans and Critical Transformations of Whiteness," *boundary* 2, no. 28 (2001); and Claire Jean Kim, "The Racial Triangulation of Asian Americans," *Politics and Society* 27, no. 1 (1999): 105–138.
4. Micah Rajunov and Scott Duane, eds., *Nonbinary Memoirs of Gender and Identity* (New York: Columbia University Press, 2019), xvi.
5. Barker and Iantaffi, *Life Isn't Binary*, 77.
6. Rajunov and Duane, *Nonbinary Memoirs*, xxvii.
7. Andrea Long Chu, *Females* (New York: Verso, 2019), 35, 38, 12.
8. Alok Vaid-Menon, *Beyond the Gender Binary* (New York: Penguin Workshop, 2020), 29.
9. Jeffrey Marsh, "Life Threats," in Rajunov and Duane, *Nonbinary Memoirs*, 76.
10. Patrice D. Douglass, "Black Feminist Theory for the Dead and Dying," *Theory and Event* 21, no. 1 (2018): 116.
11. Hortense J. Spillers, "Mama's Baby, Papa's Maybe: An American Grammar Book," in *Black, White, and in Color: Essays on American Literature and Culture* (Chicago: Chicago University Press, 2003), 206.
12. C. Riley Snorton, *Black on Both Sides: A Racial History of Trans Identity* (Minneapolis: University of Minnesota Press, 2017), 57.
13. Douglass, "Black Feminist Theory," 111.

14. Inspired by Spillers, this phrase is used by Frank B. Wilderson III. See his interview with Zamansele Nsele, "Part I: 'Afropessimism and the Rituals of Anti-Black Violence," *Mail and Guardian*, June 24, 2020, https://mg.co.za/article/2020-06-24-frank-b-wilderson-afropessimism-memoir-structural-violence/.
15. See Tourmaline, Eric A. Stanley, and Johanna Burton, eds., *Trap Door: Trans Cultural Production and the Politics of Visibility* (Cambridge, MA: MIT Press, 2017).
16. Anne Anlin Cheng, *Ornamentalism* (Durham, NC: Duke University Press,), 22, 4, 156, 2–3, 19, xi. See also Uri McMillan, *Embodied Avatars: Genealogies of Black Feminist Art and Performance* (New York: New York University Press, 2015).
17. Kate Bornstein and S. Bear Bergman, *Gender Outlaws: The Next Generation* (Berkeley, CA: Seal Press, 2010), 16.
18. Cheng, *Ornamentalism*, 4, emphasis mine.
19. Jose Esteban Muñoz, *The Sense of Brown* (Durham, NC: Duke University Press, 2020), 2, emphasis mine.
20. Amardeep Singh, "Shades of Brown: Notes for a South Asian American Media Studies Project," *Electrostani*, May 22, 2018, http://www.electrostani.com/2018/05/shades-of-brown-notes-for-south-asian.html.
21. Into the binary of Indigenous/settler, for instance, Indigenous theorist Jodi Byrd has introduced a third term, "arrivant," to describe the position of forced migrants such as enslaved people, their descendants, and other unwilling settlers of North America. Arrivant is a position sometimes claimed by Asian immigrants and refugees to refer to the complicated conditions of our displacement or exile here—on Turtle Island, as its native inhabitants called it, before they were renamed after a mythical India—following colonization and war-making in our own ancestral lands, and such a subject position may or may not involve a desire for neutrality. See Jodi Byrd, *Transit of Empire:*

Indigenous Critiques of Colonialism (Minneapolis: University of Minnesota Press, 2011).

22. Koshy, "Morphing Race," 190.
23. Ren Ellis Neyra, "The Question of Ethics in the Semiotics of Brownness," *SX Salon* 35 (October 2020), http://smallaxe.net/sxsalon/discussions/question-ethics-semiotics-brownness/.
24. Koshy, "Morphing Race," 167.
25. Kai Cheng Thom, *Fierce Femmes and Notorious Liars: A Dangerous Trans Girl's Confabulous Memoir* (Montreal: Metonymy, 2018), 60, 61–62.
26. Kara Keeling, *The Witch's Flight: The Cinematic, the Black Femme, and the Image of Common Sense* (Durham, NC: Duke University Press, 2007), 149, 146.
27. Jared Sexton, "Properties of Coalition: Blacks, Asians, and the Politics of Policing," *Critical Sociology* 36, no. 1 (2010): 98, 100.
28. Roland Barthes, *Empire of Signs*, trans. Richard Howard (New York: Hill and Wang, 1982), 89. First published 1970 by Editions d'Art Albert Skira SA.
29. Barthes, *Empire of Signs*, 53, 89. See also Benjamin Hiramatsu Ireland, "Memoirs of a Gaysha: Roland Barthes's Queer Japan," *Barthes Studies* 4 (2018): 2–30.
30. Calvin Warren, *Onticide: Afropessimism, Queer Theory, and Ethics* (Ill Will Editions, 2015), 6, https://illwilleditions.noblogs.org/files/2015/09/Warren-Onticide-Afropessimism-Queer-Theory-and-Ethics-READ.pdf.
31. If there is such a thing as Asian optimism, then it is interrogated by incisive scholarship on the model minority myth, including but certainly not limited to: Eve Oishi, "Bad Asians: New Media by Queer Asian American Artists," in *Countervisions: Asian American Film Criticism*, ed. Darrell Hamamoto and Sandra Liu (Philadelphia: Temple University Press, 2000); Viet Thanh Nguyen, *Race and Resistance: Literature and Politics in Asian America* (New York: Oxford University Press, 2002);

Crystal Parikh, *An Ethics of Betrayal: The Politics of Otherness in Emergent U.S. Literatures and Culture* (New York: Fordham University Press, 2009); Eleanor Ty, *Asianfail: Narratives of Disenchantment and the Model Minority* (Urbana: University of Illinois Press, 2017); David L. Eng and Shinhee Han, *Racial Melancholia, Racial Dissociation: On the Social and Psychic Lives of Asian Americans* (Durham: Duke University Press, 2018); John Streamas, "Asia-Pessimism: Modeling a Revolution in Failure," *The Comparatist* 43 (2019): 112–124; erin Khuê ninh, *Passing for Perfect: College Impostors and Other Model Minorities* (Philadelphia: Temple University Press, 2021); Takeo Rivera, *Model Minority Masochism: Performing the Cultural Politics of Asian American Masculinity* (New York: Oxford University Press, 2022).

32. Nsele, "Part I: 'Afropessimism.'"
33. Roland Barthes, *The Neutral: Lecture Course at the Collège de France (1977–1978)*, trans. Rosalind E. Krauss and Denis Hollier (New York: Columbia University Press, 2005), 211, 105, 8.

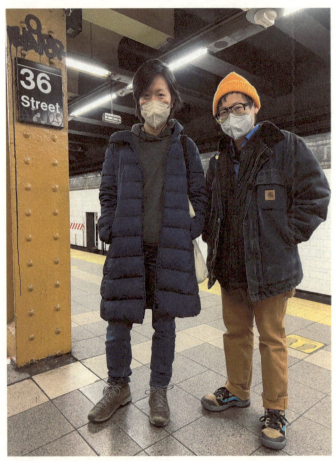

Stephanie Hsu and Ka-Man Tse. Photo by Jonas St. Juste.

Notes on Contributors

S. L. CLARK (they/he) is the editor of *Out of Salem* by Hal Schrieve (longlisted for the 2019 National Book Award for Young People's Literature) and *All City* by Alex DiFrancesco (2020 Ohioana Book Awards Finalist in Fiction). Though they have worked on various kinds of books, they prioritize acquiring texts written by or about people who are queer, trans, women, or POC. They have worked with authors such as adrienne maree brown, Khary Lazarre-White, and Luis J. Rodriguez. They are currently the program director of Drag Story Hour NYC, and the editor of the Black Dawn Series under AK Press, a speculative novella series. Their bookcase is filled with YA, fantasy, sci-fi, mystery, horror, plays, and queer literature. Clark is also involved in performance art and cosplay and can often be found purchasing large quantities of fake blood and tulle. They're addicted to ramen, cat photos, tea, and Doctor Who paraphernalia. A perfect day to Clark involves lots of green tea while relaxing with a good book or anime and cuddling one of their three cats. They really love cats. They live in Brooklyn, New York.

STEPHANIE HSU (she/they) teaches and writes in the fields of Asian American studies and queer and trans studies about

the embodiment of race, gender, desire, and drive. Raised Taiwanese American in the U.S. South, Stephanie is an associate professor of English at Pace University in New York, a recipient of the 2020 Community Catalyst Award from the National Queer Asian/Pacific Islander Alliance, and an editorial collective member for the Q+ Public book series. Special acknowledgment for making this volume possible goes to Q+ Public series cofounder and infinitely more, Jeffrey Escoffier (1942–2022). Stephanie lives in Brooklyn, New York.

IGNACIO G HUTÍA XEITI RIVERA (Ig-Nah-See-Oh Gee Who-tee-ah She-eye-tee Ree-ve-Rah) (they/them), M.A., is an internationally known gender fluid speaker, trainer, and consultant. They are a longtime activist, performer, writer, and healer. Ignacio is also a cultural sociologist and sexual liberationist, with expertise in sexual trauma, healing, and liberation for marginalized people. They are the founder and co–executive director of the HEAL Project, working to prevent and end child sexual abuse through healing the wounds of sexual oppression and embracing sexual liberation. Their performances have been grounded in liberation and healing, with intersectional focus on gender, survivorship, sexuality, and sexual violence prevention, specifically as it relates to marginalized folks. Their written work has appeared in *ColorLines*, *Ebony*, and *Yellow Medicine Review*. They have contributed to many anthologies, including *We Too: Essays on Sex Work and Survival*, edited by Natalie West and Tina Horn; *Coming Out Like a Porn Star*, edited by Jiz Lee; *Love WITH Accountability: Digging Up the Roots of Child Sexual Abuse*, edited by Aishah Shahidah Simmons; *Friendship as Social Justice Activism*, edited by Niharika Banerjea, Debanuj Dasgupta, Rohit Dasgupta, and Jaime Grant; *Girl Sex 101*,

edited by Allison Moon; and *Trans Bodies, Trans Selves*, edited by Laura Erickson-Schroth. They live in Decatur, Georgia. HEAL2End.org and IGRivera.com

ARI SOLOMON (they/them) is currently an executive assistant at the nonprofit HeartShare St. Vincent's Services and serving on their LGBTQ Committee. As a brand ambassador for SmartGlamour, an ethical, diverse, and eco-conscious clothing line, Ari has modeled across various seasons for the fashion line. They were featured as model of the month in February 2019 and interviewed on the SmartGlamour podcast to discuss fashion and modeling. Ari is a performer at heart and is part of the queer artist collective known as NDNTFD, serving as contributing artist and treasurer. They enjoy trying new food, supporting their friends at drag shows, watching anime, and playing video games. When not working, performing, creating, or consuming art, Ari spends time with their partner and their three cats together and hopes to travel and see more of the world in the future. They live in Brooklyn, New York.

JONAS ST. JUSTE (xe/xem/xyrs/he/him/his) is an artist, recent cat dad, guerrilla gardener, and novice hiker born in 1995 and living in Harlem, New York City. A former Pace University student, St. Juste founded an anarchist group while in college called The Ungovernables that was completely autonomous from the university's control. The group made and distributed DisOrientation Guides and organized prisoner letter-writing groups. Nowadays, St. Juste enjoys xyr time connecting with the environment and land around him. As an emerging photographer, xe explores a variety of subjects in personal still lifes and landscape.

KA-MAN TSE (she/they) is an artist and educator. Ka-Man has exhibited her work at Para Site, Videotage, Lumenvisum, and Eaton Workshop, all in Hong Kong. In the United States, she has mounted solo shows at Aperture in New York and the Silver Eye Center for Photography in Pittsburgh, Pennsylvania. Recent exhibitions include Art on the Stoop: Sunset Screenings at the Brooklyn Museum, Chosen at the Leslie Lohman Museum in New York, and Tate Lates at the Tate Museum in London. She is the recipient of the Robert Giard Fellowship, a Research Award from the Yale University Fund for Lesbian and Gay Studies, the Aperture Portfolio Prize, and the Aaron Siskind Fellowship and was an Artist-in-Residence at Light Work in Syracuse, New York. She has taught at Cooper Union and Yale School of Art and is currently director of BFA Photography at Parsons. Her monograph is titled *narrow distances*, and her writing has also been published in *Best! Letters from Asian Americans*, edited by Christopher K. Ho and Daisy Nam, and *Photo No Nos*, edited by Jason Fulford. Special acknowledgment for making this volume possible goes to Hannah Wong and Hee Eun Chung. Ka-Man lives in Brooklyn, New York.

Available titles in the Q+ Public series:

E. G. Crichton, *Matchmaking in the Archive: 19 Conversations with the Dead and 3 Encounters with Ghosts*

Shantel Gabrieal Buggs and Trevor Hoppe, eds., *Unsafe Words: Queering Consent in the #MeToo Era*

Andrew Spieldenner and Jeffrey Escoffier, eds., *A Pill for Promiscuity: Gay Sex in an Age of Pharmaceuticals*

Alexander McClelland and Eric Kostiuk Williams (illus.), *Criminalized Lives: HIV and Legal Violence*

Stephanie Hsu and Ka-Man Tse, eds., *My Race Is My Gender: Portraits of Nonbinary People of Color*